Florida's Lost Tribes

UNIVERSITY PRESS OF FLORIDA
STATE UNIVERSITY SYSTEM

Florida A&M University, Tallahassee
Florida Atlantic University, Boca Raton
Florida Gulf Coast University, Ft. Myers
Florida International University, Miami
Florida State University, Tallahassee
University of Central Florida, Orlando
University of Florida, Gainesville
University of North Florida, Jacksonville
University of South Florida, Tampa
University of West Florida, Pensacola

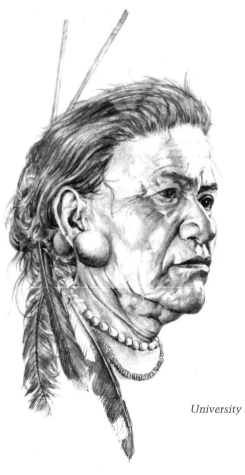

FLORIDA'S

University Press of Florida

Gainesville

Tallahassee

Tampa

Boca Raton

Pensacola

Orlando

Miami

Jacksonville

Ft. Myers

LOST TRIBES

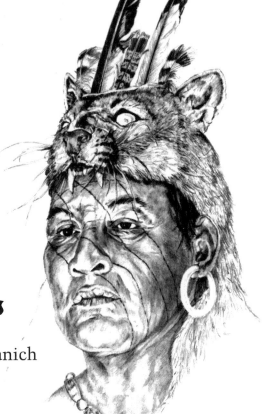

THEODORE MORRIS

with commentary by Jerald T. Milanich

09 08 07 06 05 04 6 5 4 3 2 1

Library of Congress Cataloging-in-Publication Data
Morris, Theodore.
Florida's lost tribes / Theodore Morris; with commentary
by Jerald T. Milanich.
p. cm.
Includes bibliographical references.
ISBN 0-8130-2739-X
1. Indians of North America–Florida–Antiquities. 2. Indians of North
America–Florida–History. 3. Indians of North America–Florida–Pictorial
works. I. Milanich, Jerald T. II. Title.
E78.F6M67 2004
975.9'01–dc22 2004049467

The University Press of Florida is the scholarly publishing agency for the
State University System of Florida, comprising Florida A&M University,
Florida Atlantic University, Florida Gulf Coast University, Florida Interna-
tional University, Florida State University, University of Central Florida,
University of Florida, University of North Florida, University of South
Florida, and University of West Florida.

University Press of Florida
15 Northwest 15th Street
Gainesville, FL 32611-2079
http://www.upf.com

CONTENTS

Florida's Lost Tribes

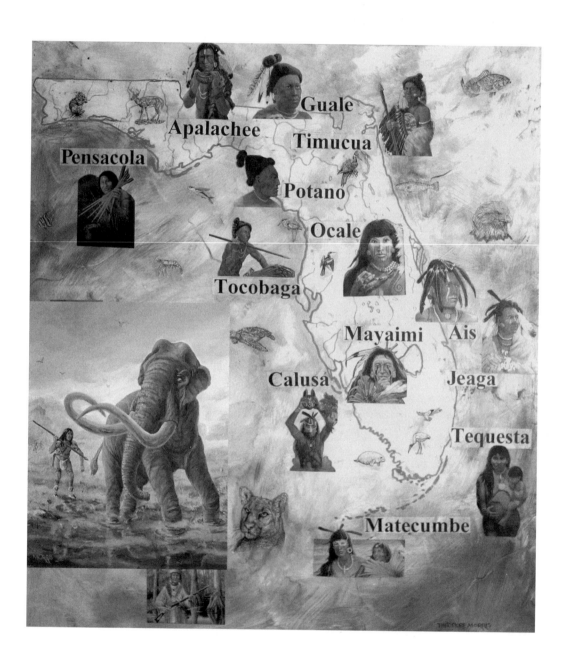

PORTRAYING FLORIDA INDIANS

A collaboration between an artist and an archaeologist? Why not? We have more in common than one might think. Both of us share a deep interest in the history of Florida and the American Indians who once lived there. Both of us also are dedicated to making twenty-first-century people aware of Florida's native cultures lost in the mists of long-forgotten centuries. What were the people like who lived in Florida in the past? What did they look like? How did they live? These are exciting questions for which we strive to find answers.

In this volume, artist Theodore Morris uses oil paintings and pencil drawings as a visual language to depict Florida's native cultures. He has worked with archaeologists and anthropologists throughout Florida and has spent many hours helping excavate sites to gather the latest artifact data and other information for his paintings.

Morris's realistic images of the ancient people described here are not romantic, but demonstrate a sensitive understanding of their way of life. His objective is to bring Florida's fascinating forgotten and vanished tribes back to life. By creating a pictorial record through paintings, drawings, and research—a body of work similar to that of George Catlin, who painted portraits and scenes of American Indians more than a century ago—Morris contributes to their legacy.

I am one of the archaeologists with whom Morris consulted about the Indians of Florida. Though I started college as a mathematics major, a stint on an archaeological excavation at a pre-Columbian site in the Lake Okeechobee Basin quickly steered me from matrix theory to learning about the native groups who once lived in Florida. As a mu-

seum curator, my goal, like that of Theodore Morris, is to bring the past into the present, educating people about the Florida cultures that antedated their own.

Florida's Lost Tribes combines Morris's artistic skills with my commentary. The book is intended to be a unique blend of art and archaeology that provides readers with background about the Florida Indians, while sharing Morris's insights into the creative process behind each of his paintings. For the reader who wants to learn more, I provide a book list as well as the URL for a Web site that links to a host of pages treating Florida's lost tribes. Working together, artist and archaeologist strive to give readers a vista of the past.

Picturing Paradise?

Theodore Morris is not the first artist to paint Florida's Indians. In 1590, nearly a century after the initial voyage of Christopher Columbus, a Flemish engraver, Theodore de Bry, and his family began the publication of fourteen illustrated books on the Americas. All contain etchings depicting scenes and people from the New World, along with narratives describing the people and the lands as seen through European eyes. The second volume, published in 1591 in both Latin and German editions, focuses on Florida, especially the 1564–65 French settlement, Fort Caroline, once located on the south bank of the St. Johns River east of modern Jacksonville (no trace of the fort or the small French settlement adjacent to it has ever been found), and the Timucua Indians who lived nearby. The text is accompanied by forty-two etchings showing the Atlantic coast of the southeastern United States, the French fort and its soldiers and settlers, and especially the Timucua Indians.

In 1946 Stefan Lorant published *The New World, the First Pictures of America*, therein translating de Bry's Florida text and reproducing the etchings, including the Florida map that had accompanied the 1591 volume. Lorant relates how one member of the 1564–65 French expedition to Florida, Jacques Le Moyne de Morgues, who had signed on as a cartographer, painted a series of watercolors depicting the Florida Indians. Though Le Moyne might have done the paintings while he was at Fort Caroline, scholars think he probably created them after he returned home from Florida in 1565. Arriving back in Europe, Le Moyne first lived in France, but due to political problems, soon moved to England where he lived in Blackfriars, a London neighborhood. It is likely Le Moyne did most if not all of his watercolors while living in

This woodcut appeared in 1557 in Chapter 28 of Hans Staden's Warhaftige Historia Und Beschreibung Eyner Landtschafft Der Wilden Nacketen Grimmigen Men, *published in Frankfurt.*

Blackfriars. After his death in 1588, his widow is said to have sold Le Moyne's artworks to Theodore de Bry, who used them as the basis for his 1591 engravings. Or so the story goes.

The de Bry engravings of the Florida Timucua Indians have long been thought to be among the earliest European depictions of Indians in what is now the mainland United States. Almost as soon as they were first issued in 1591, other artists and engravers borrowed liberally from them for use in other books to illustrate what Florida Indians may have looked like. In no time at all they also were used as surrogates for other native peoples in the Americas and even in the Far East. As they say, de Bry's engravings of Le Moyne's paintings "got legs." In succeeding centuries, various versions and copies of the engravings have been reissued; some have even been "colorized."

The importance of the de Bry engravings is based on several factors. First, they are the earliest sixteenth-century, firsthand depictions of the Florida Indians. Second, the engravings contain extraordinary ethnographic detail, showing the Indians' village layouts; foods and food preparations; their tattoos, dress, ceramics, and tools; their hunting techniques; their war, burial, and other ceremonies; and a host more activities. Though rendered in the style of European images of the time, they provide a privileged view into the past. Third, that view is of a people who were on the verge of great change. The coming of

André Thevet's engraving from his 1557 edition of Les Singularités de la France Antarctique, *published in Paris (folio 77, recto).*

Europeans to the southeast United States would trigger events that permanently altered the cultures and populations of the native inhabitants. Eventually, the Florida Indians would disappear under the onslaught of colonialism. The de Bry engravings show us what once was; there are no descendants of the Timucua Indians to tell us about their ancestors.

Lorant's 1946 book (a second edition was issued in 1952) for the first time made de Bry's Florida engravings and what has come to be known as the Le Moyne map—a map commonly thought to have been crafted by Le Moyne—widely available to artists, historians, archaeologists, museum curators, and others interested in the native peoples of Florida. There is hardly a book, museum exhibit, or Web page dealing with Florida Indians that has not made use of these engravings. Generations of student scholars have pored over details in the engravings, producing studies of such things as Timucua Indian tattoo motifs relative to the native social system.

The Le Moyne map, which covers Florida, charts the location of numerous native groups throughout the state. It provides unprecedented geographical knowledge about the Florida Indians, information many of us have put to use in our books. Some modern investiga-

tors have prepared detailed analyses of Indian tribal locations relative to modern landmarks based on that map.

The de Bry engravings are a rare treasure. They portray the Florida Timucua Indians as they lived prior to the colonial period and the changes wrought by European settlement of the southeast United States, including Spanish efforts to Christianize the Timucua by organizing them into numerous missions. The original de Bry engravings date from a time when the people of the Americas were viewed as exotic by Europeans, who thirsted for information about the new world Columbus had found.

Some Europeans characterized the Americas prior to the colonial conquest as a sort of Eden, a paradise unsullied by the intrusion of strangers from across the Atlantic. Though that view has long been rejected, there is no doubt the de Bry engravings have preserved a unique record of what once was. Or have they?

Paradise Lost

Scholars have long lamented the loss of all but one of Jacques Le Moyne's original watercolor paintings of Florida and the Timucua Indians. Measuring just over seven by ten inches, that single small Florida painting attributed to Le Moyne is housed in the New York Public Library. Fortunately, the posterity of many other Le Moyne paintings and drawings is assured. Fifty-nine reside in the Victoria and Albert Museum in London, and a sketch book attributed to Le Moyne, which includes paintings on twenty-nine pages, can be found in the Pierpont Morgan Library in New York City. Still other Le Moyne paintings belong to private collections. There also is a book of embroidery patterns, *La Clef du Champs*, which Le Moyne published himself in London in 1586, containing woodcuts based on his designs. Only three incomplete copies of this small book are known to exist.

Except for the New York Public Library painting, all the existing Le Moyne paintings and drawings depict plants, animals, and insects, and none appears to relate to Florida. They almost certainly were painted when Le Moyne was living in London well after he had returned from Fort Caroline. Indeed, Le Moyne's artistic reputation is based on his natural history renderings. Some of those paintings, as well as a catalogue, are reproduced in Paul Hulton's 1977 two-volume study, *The Work of Jacques Le Moyne de Morgues, a Huguenot Artist in France, Florida and England.*

Despite the loss of Le Moyne's Florida paintings (save one), most scholars have been reasonably secure in their belief that, in making his engravings, Theodore de Bry accurately copied from the paintings then in his possession. Documentation indicating de Bry bought Le Moyne's paintings from his widow supports the contention that de Bry based his engravings on Le Moyne's work. It is also thought that, during their careers, de Bry met Le Moyne and that Le Moyne made available to de Bry the narrative of his La Florida adventures.

In 1971–72 while working on a post-doctoral fellowship at the Smithsonian Institution's National Museum of Natural History under the tutelage of renowned American Indian scholar, William C. Sturtevant, I had the opportunity to look at the de Bry engravings in detail while writing about the Timucua Indians. Four things were immediately apparent. First, the French soldiers depicted in the engravings are wearing their helmets backwards. Secondly, one of the engravings which shows Timucua Indians drinking black drink—a native tea brewed from leaves of parched yaupon holly (*Ilex vomitoria*) and ingested on ceremonial occasions—has them drinking from nautilus clam shells, not from whelk shell cups. There were no nautilus shells in Florida, and it is known the Timucua and other southeastern Indians took their black drink from shell cups, sometimes elaborately inscribed, fashioned from large whelks. The shells used to make these cups commonly were *Busycons* with their columellae removed. Third, many of the feather headdresses worn by the Timucua, as well as the wooden clubs some of them are wielding look like those associated with Amazonian Indians, such as the Tupinamba from Brazil. And, fourth, some of the scenes in the engravings are of events which took place in 1562 when a French expedition first visited the southeast coast of the United States, including Florida. Jacques Le Moyne was not on that 1562 expedition; how then could he have made paintings based on firsthand knowledge? Other obvious mistakes in the engravings exist and have been noted by other researchers, including Carl Sauer in his 1971 book, *Sixteenth Century North America*. Taken together, such observations call into question the supposition that there is a one-to-one correlation between a specific, lost Le Moyne painting and each de Bry engraving.

Three years later, in 1974, one of my undergraduate students at the University of Florida, Janet McPhail, began an in-depth study of the de Bry engravings, comparing scenes of the Florida Timucua with scenes of Brazilian Indians recorded by sixteenth century Europeans prior to 1591. Her discoveries, written up in her 1975 honors thesis, are a bit startling. De Bry not only borrowed headdresses from Brazilian Indi-

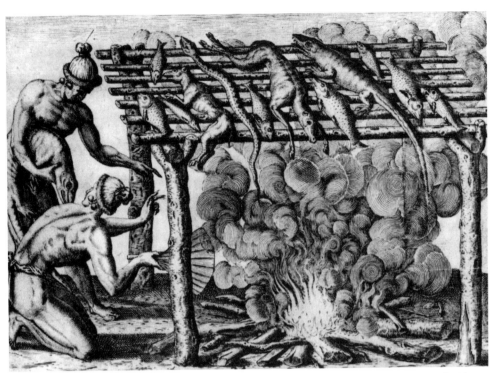

Engraving 24 from Theodore de Bry's 1591 Brevis narratio eorum quae in Florida Americae Provincia, *published, in Latin, in Frankfurt. Note the person with the fan in both the Staden drawing and this image.*

ans for his Florida engravings of the Timucua, but he lifted whole scenes from drawings and engravings of Brazilian Indians published by people like Hans Staden, a German shipwrecked on the Atlantic coast of South America in the mid-sixteenth century, and André Thevet, who published books on the native peoples of the Americas. Thevet, in turn, apparently drew on Staden's drawings and other sources for his books' illustrations. Staden's account (entitled in English *The True History of His Captivity*), including his illustrations, was first published in Europe in 1557, while Thevet published his books from 1557 to 1584. De Bry was certainly aware of Staden's account; he used it in another of his volumes on the Americas published in 1593.

William Sturtevant, who has continued his interest in the ethnographic information which can be gleaned from early depictions of American Indians, has published articles documenting the use of illustrations of Brazilian Indians to depict aspects of the cultures of North American Indian groups in addition to the Timucua. He has aptly called this the "Tupinambization" of North American Indians. Writing about the de Bry engravings specifically, Sturtevant has noted that none of the ethnographic details portrayed in the de Bry engrav-

ings can now be accepted at face value; all are suspect and must be corroborated from other sources. The de Bry engravings should not be totally accepted as fact.

Was de Bry a bad guy? A forger? Not at all. De Bry did not seek to accurately portray the Florida Timucua Indians in his book. His engravings were meant to entertain readers, not provide a true ethnographic record. That was true not only of de Bry's illustrations, but those produced in Europe by other publishers in the sixteenth and seventeenth centuries. Illustrators used the sources at hand to try and portray what they thought their subjects might have looked like. Because there were no copyright laws, they borrowed freely from existing written narratives and illustrations. Just as de Bry used whatever information he could in his books, so other engravers, illustrators, and authors borrowed from him.

If all that is true, why did de Bry not rely more heavily on Le Moyne's Florida paintings? If he had them, why not use them? I honestly question whether Jacques Le Moyne actually did any paintings or drawings of Florida Indians at all. Nothing related to Florida is found in his paintings of plants, insects, and animals done after he returned from Fort Caroline. And the attribution of the one surviving Le Moyne Florida painting has now been called into question. [That attribution has been based both on the similarity to the de Bry engraving of the same scene and to a late-nineteenth- or early-twentieth-century inscription on the engraving; see Paul Hulton's description of the painting in the first volume of his 1977 two-volume study of Le Moyne's art.] In a 1988 article in the *European Review of Native American Studies*, anthropologist Christian F. Feest convincingly argues that the painting is actually a later copy of the engraving, not vice versa. The painting with its pink-skinned Indians was never done by Jacques Le Moyne, who died in 1588.

The supposition that Le Moyne painted or drew pictures of Florida Indians is based on a note stating he was being paid by Sir Walter Raleigh to do color illustrations of the French colony in Florida. But it is not known if they actually were ever done and, if so, what happened to them. What if the Le Moyne paintings sold by his widow to Theodore de Bry were depictions of plants and animals, perhaps the paintings which today are in museum and library collections?

Could it be de Bry engraved scenes based on the French narratives about the two expeditions to Florida and the southeast United States (in 1562 and 1564–65) rather than on sketches or paintings? Did de Bry supplement those French narratives along with illustrations from

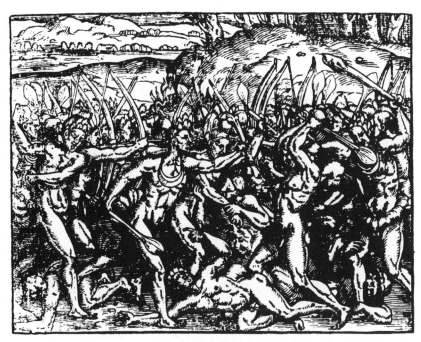

Engraving from André Thevet's 1557 book (folio 71, verso).

Hans Staden and André Thevet and other sources? Until bona fide Le Moyne paintings of Florida are found, these are very real possibilities.

We have not yet discussed the narrative supposedly written by Jacques Le Moyne, which de Bry published to accompany the engravings in his 1591 volume. Did Le Moyne ever actually author such a document? Most of the information contained in the narrative (as well as in large portions of the respective captions published with each of the de Bry engravings) reproduces information contained in other of the French narratives treating the two French expeditions to Florida and the south Atlantic coast of the United States. I believe the authorship of that particular narrative also is very much in doubt.

More certain is something amiss in the captions accompanying the de Bry Florida engravings. Some clearly plagiarize French narratives other than Le Moyne's account. Further, a comparison of captions published in the 1591 German translation of the book with those in the Latin version of the same book shows some peculiar differences. For instance, next to the engraving of Indians shoving a pole down an alligator's throat, the German text states that the reptiles were killed by having arrows shot into them, while the Latin version claims clubs and spears were used to hammer on and cut the animals open. And while the German account notes that ten or twelve Indians manned the tree trunk impaling the alligator, the Latin version uses the same

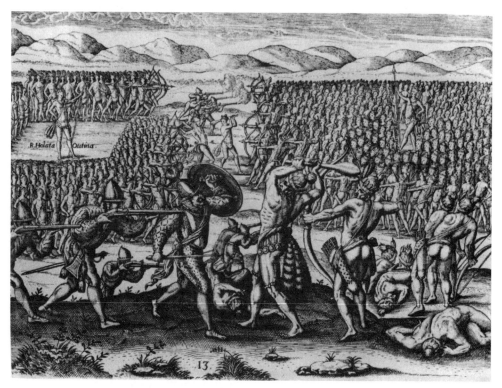

Engraving 13 from Theodore de Bry's 1591 book. Note the similarities in clubs and headdresses to Thevet's engraving.

numbers but with reference to tree trunk length, stating the trunk was ten or twelve feet long. Different people apparently wrote different captions.

In *Sixteenth Century North America* (1971), Carl Sauer writes of that portion of the narrative accompanying one of de Bry's engravings, "Le Moyne did not write that text [the narrative in de Bry] nor did he supervise the engraving" (211). We might expand Sauer's comments to argue that neither did Le Moyne write any of the captions for the engravings.

The preceding comparison of the German and Latin versions of the same de Bry caption was published by John Faupel in the 1992 book *A Foothold in Florida, The Eye-Witness Account of Four Voyages made by the French to that Region* (translated by Sarah Lawson). In that same book, Faupel makes another Le Moyne-shattering discovery. The so-called Le Moyne map which scholars have spent hours poring over almost certainly was not done by Le Moyne at all. It contains information not known to the French in 1565. Indeed much of the information contained in the map probably comes from later Spanish sources. Most likely, de Bry had the map drawn by a contem-

porary, and its accuracy must be questioned. Le Moyne had nothing to do with it.

The map, along with the engravings and the text—all are devices incorporated by de Bry into his book to help him sell copies. He wanted to base his volume on someone who had been to Florida and seen that new land and its people. Le Moyne fit the bill.

Is that bad? Not at all. Once we understand that those visual images were never meant to be precise depictions of the Florida Indians and can only be used as ethnographic sources with a great deal of care, we can still enjoy them for what they are: early European portrayals of the Florida Indians.

Paradise Regained?

What makes Theodore Morris's paintings of the Florida Indians any more accurate than Theodore de Bry's engravings of the Timucua first published more than four centuries ago? A lot of new information based on solid research (see Morris's commentary below). In the fifty plus years since Stefan Lorant published the de Bry engravings in 1946, archaeologists and historians have excavated sites and studied documents to learn about the Timucua and other of the Florida Indians and their pre-Columbian ancestors. In 1946, only a double handful of researchers had focused on Florida's Indians. Since that time, literally hundreds of professional, student, and avocational archaeologists and historians have produced a treasure trove of knowledge. As noted above, it is this information that Theodore Morris has incorporated in his paintings. Florida's once-lost native American tribes have been found.

Theodore Morris Comments on His Paintings

My work treating Florida's lost tribes started in 1990, soon after I illustrated a poster of an Apalachee birdman dancer as part of a fund-raising project for the Florida Anthropological Society. At that time, I'd been a commercial and graphic artist for a number of years, and I wanted to use my talents for something more professionally meaningful. Then one day I happened upon a poster. Consisting of text and small illustrations of Florida's major Indian tribes, its focal point was a large line drawing of a birdman dancer based on the image embossed on a pre-Columbian copper plate excavated at the Lake Jackson site near Tallahassee, Florida. That fall day in 1990, as I studied the poster,

I wondered: what would the birdman look like painted in full color? And so it began.

George Luer, an archaeologist of keen insight and dedication, was especially helpful at this time, making sure I used proper artistic restraint to maintain accuracy. This quest for accuracy proved demanding, given the relative lack of concrete materials to work with. During my research for the fund-raising poster whose birdman image first inspired me, I discovered there were almost no images of Florida's first peoples. And so I decided to fill that void.

In filling this void, though, I first had to educate myself about those lost tribes. I began to crisscross the state in search of information, traveling to libraries and museums, talking to archaeologists and historians, and joining in archaeological digs myself. It certainly is a thrill to excavate a piece of pottery last touched by a Florida Indian thousands of years ago.

Further inspired by my education on the lost tribes of Florida, I decided to paint all the major tribal groups along with their regional artifacts, basing my images on European descriptions and other archaeological and historical information. In terms of time periods, this proved a significant undertaking: Florida's indigenous tribes lived as far back as 13,000 years ago and continued into the mid-1700s.

Five hundred years ago, Florida's tribes faced a technologically advanced enemy with weapons unknown to them. In some ways, I can relate to what happened to these people after the arrival of the Spanish conquistadors. Being a combat medic in Vietnam gave me personal insight into what happens when an advanced industrial culture invades a primarily rural culture. The Spaniards arrived in Florida with a superior attitude and disdain for the native peoples, not unlike the United States military in Vietnam. A common denominator between the sixteenth-century Spanards and the twentieth-century American military was the notion that the end would justify the means. The end in the case of the original Florida tribes is that none of them survive to this day.

I feel that my paintings and research contribute to retrieving and preserving the legacies of Florida's native peoples. I like the idea of bringing Florida's Indians back through the mists of time into the present.

These paintings are like a puzzle and very fascinating to me. The idea of doing something that's never been done before and leaving behind something of merit, both historically and artistically, really appeals to me. In the past, there was much misinformation as to what these people looked like, what they wore, how they lived their lives.

That is why I spend so much time documenting the tribes as accurately as possible.

Each of my artworks reproduced here is titled and accompanied by captions that serve several purposes. First, they name the tribal affiliation of the Indian or Indians portrayed. For paintings depicting pre-Columbian peoples, I note the associated archaeological cultures. Purists may argue that tribal names should not be assigned to pre-Columbian Indians (for instance, the Potano Indians are associated with the Alachua culture), but I plead poetic license. As appropriate, I also have attached a culture name to the colonial period tribes, although, as Jerry Milanich notes in his narrative, this is sometimes more difficult than one might think. Next, I try to convey in my captions some of the creative thinking that went into my art. Finally, each contains a brief list of the artifacts and objects portrayed. These items are based on information drawn from historical documents and from actual artifacts recovered in archaeological excavations. Many of those artifacts are discussed in the books that comprise the "Suggested Readings" section.

I would like to acknowledge the unselfish archaeologists, historians, and scholars who assisted me toward my goal of completing a work of large scope—paintings covering entire communities of people from each of the major tribes over thousands of years. These generous people—who sent me photographs and drawings of artifacts they had researched and who reviewed the final paintings for inaccuracies—include the archaeologists George Luer, Jeff Mitchem, Jerry Milanich, Ryan Wheeler, Bill Marquardt, Ann Cordell, and Bob Carr. Jim Lord graciously provided me input on the Tequesta tribe. Dorothy Downs and Brent Weisman offered useful criticism of my Seminole drawings and paintings, and I sincerely appreciate the encouragement and enthusiasm extended by Marion Almy, Joan Deming, and all my colleagues in the archaeological and historical communities. I would also like to thank Kris Rowland, Claire and Bill Matturro, and Barbara Figlow for helping me develop my captions. Finally, Mallory O'Connor and Marvin T. Smith were kind enough to review and comment on a draft of this book. Jerry Milanich and I are grateful for their efforts.

2 ANCIENT INDIANS

Fourteen thousand years ago, perhaps centuries earlier, what is now the state of Florida was first inhabited by American Indians whose ancestors had entered North America from eastern Asia during the Pleistocene epoch, the Great Ice Age. Exactly when and how those first humans crossed the land bridge connecting Siberia with Alaska and made their way south and eastward is a topic of great debate among modern scholars. Some archaeologists even argue that humans arrived in North America not by land, but by sea; others believe the arrival of humans in North America took place twenty or more millennia in the past. Though the peopling of North America continues to be a topic of contention, the evidence at hand indicates the presence of Indians in Florida about fourteen millennia ago.

The Paleoindians

These earliest Floridians, we call them Paleoindians—literally, Ancient or Old Indians—found a land different from today's Sunshine State. Florida's total land surface was then about twice its present size, the result of sea levels more than three hundred feet lower than they are today. Where was all the water? In gigantic glaciers that blanketed portions of the continents.

It was only after the massive Ice Age glaciers started melting about 11,000 years ago that the oceans began their slow, uneven rise to modern levels. That process inundated Florida's Pleistocene shoreline and

eventually gave the state its present configuration. Fluctuations in sea level continue to shape Florida's coasts today.

With so much water contained in the Ice Age glaciers, the Florida of the Paleoindians was drier than it is today, and it also was cooler. Scrub vegetation, open grassy prairies, and savannas were common. From this environment the Paleoindians collected a variety of plants and small animals for food. They also hunted larger animals, including several Ice Age species now extinct, such as *Bison antiquus* (a much larger version of our modern bison), mammoths and mastodons, Pleistocene horses (similar in appearance to modern horses), and giant land tortoises. One weapon they used was an atlatl or spear-thrower, a hand-held device that allowed Indians to hurl stone-tipped spears with great force. Paleoindians probably also fished and collected shellfish, but their coastal encampments now lie under the Gulf of Mexico and the Atlantic Ocean, and archaeologists are only now beginning to perfect techniques to investigate sites which lie offshore under water. We still have much to learn about these early coastal sites.

Because sea levels were lower and Florida was significantly drier, the rivers, lakes, and springs so common today were not present at the end of the Ice Age. Paleoindians and many of the animals they hunted were forced to seek watering holes where they could obtain water for drinking and for other purposes. At these freshwater sources—deep natural springs and other natural depressions in limestone outcroppings where rainwater collected—the Paleoindians could ambush animals, then set up camps and butcher and eat their prey using tools made from ivory, stone, bone, and wood. Recent underwater excavations on the Aucilla River have found examples of all of these tools from Paleoindian camps.

Many of the watering holes beside which Paleoindians camped became parts of flowing rivers or springs when the amount of surface water increased in Florida at the end of the Ice age. The camps themselves, as well as the remains of animals eaten by the Indians and a variety of tools, were covered with water. Consequently, today many Paleoindian sites and artifacts are found underwater, like those in the Aucilla River.

Florida's increased wetness was part of a worldwide change that began as the Great Ice age drew to a close about 11,000 years ago. Glaciers melted and the earth's sea levels began to rise. As a consequence, Florida's climate became damper and slightly warmer, and there were more water sources. Especially along the Gulf of Mexico coast, the shoreline receded as the sea rose, leaving animals and the Paleoindians with less land over which to roam. It is amazing to think

that Paleoindians camped on land that today is beneath the Gulf of Mexico. It is even more extraordinary that archaeologist are now finding those camps under the Gulf and excavating them using SCUBA gear!

By about 9,500 years ago, the effects of climatic changes and hunting by Paleoindians caused the extinction of some of the large animals, especially plant eaters such as the elephants and horses that had flourished on Florida's Pleistocene savannas. Even so, many species of animals remained for the Florida Indians to hunt, trap, and fish. Those animals, along with a large array of wild plants, would provide sustenance for generations of Florida Indians.

Indians of the Archaic Period

Over the next several millennia following 7,500 B.C., the number of Florida Indians continued to increase, and they established new settlements, many around freshwater sources. The Paleoindian way of life gave way to a less nomadic, more settled existence. Archaeologists call this new time the Archaic period (again, meaning "ancient" or "old"). With a settled lifestyle and new animals to hunt, different types of stone tools were made. Trade networks, some encompassing much of the Southeast, sprang up. Old ways gave way to new ones.

During the Early Archaic period (7,500–5,000 B.C.), the Florida Indians used vegetable fibers to make cloth and cordage and they fashioned a large variety of tools out of wood and other raw materials. Most likely their Paleoindian ancestors did the same, but so far few such perishable items have been found. At least some Early Archaic people buried their dead wrapped in fabrics in the mucky bottoms of shallow ponds, returning over generations to make interments in the same cemetery. Just why such burials were made is not known. Perhaps water, so important in life, also was important in death.

Florida's climate continued to ameliorate, growing warmer and wetter. By the onset of the Middle Archaic period 5,000 years ago, essentially modern environmental conditions had appeared (though sea level was still lower than it is today). During this period, 5,000–3,000 B.C., Florida Indians took advantage of their improved environment and moved into new settings, including along the Atlantic and Gulf coasts and the St. Johns River. With sea levels nearing modern elevations, coastal estuaries formed, and their stocks of fish and shellfish provided perfect locales for Indian settlements. Similarly, the rise in inland groundwater tables created flowing streams and rivers like

the St. Johns River, which also held large populations of fish and shellfish—important wild food sources that could feed many mouths.

With these relatively stable food sources, Middle Archaic population continued to increase, and coastal and inland villages adjacent to salt and freshwater wetlands became the norm. Throughout the remaining history of the Florida Indians, wetlands and their fish and shellfish would always provide significant bounty for villagers.

By 3,000 B.C., the beginning of the Late Archaic period, Indians were living in almost every part of the state wherever wetlands were found. The populations of villages grew, leading to the budding off of new, daughter villages. Groups with shared histories and a once-common territory were now found in many different regions. Interactions across historically and geographically bounded groups and a lively trade both throughout and outside of Florida offered ample opportunities for innovation and the adoption of new ideas.

One invention that appeared several hundred years prior to 2,000 B.C. in the St. Johns River drainage and in southwest Florida—archaeologists are uncertain which region was first—is pottery made by firing clay. These ceramics, among the earliest in the United States, were tempered with Spanish moss or palmetto fibers to make the clay paste mixture stronger. The walls and bottoms of these vessels, called fiber-tempered pottery by archaeologists, were shaped by hand and then smoothed with scraping tools. Sometimes geometric designs were incised in the outside walls of the fiber-tempered pots before the vessels were fired.

At least by 500 B.C. and probably several hundred years earlier, Indian potters were experimenting with new techniques to make and decorate their pots. The adoption of these innovations marks the end of the Late Archaic period and the recognition by archaeologists of individual, regional cultures. By this date, the use of plant fibers as pottery tempering agents had given way to quartz sand, limestone, fuller's earth (a clay-like substance resembling potter's clay), and even freshwater sponges. Native potters could now make stronger vessels with thinner walls. They also constructed their pots by rolling out and stacking coils which were then paddled and smoothed to form vessel walls. Different groups made their ceramic vessels in different shapes and decorated them with distinctive designs, providing archaeologists an important tool in their efforts to define and study specific Florida Indian cultures over time. Indeed, in several instances, such as along the St. Johns River, we can trace the history of regional cultures from the end of the Late Archaic period into the sixteenth century and the time of the first European incursions into Florida.

3 THE ANCESTORS

The Indian groups who lived in Florida after 500 B.C. each tended to live within specific environmental, physiographical, or geographical zones. Examples are the coast and interior wetlands of northeast Florida; the interior forests, lakes, and other wetlands of north-central Florida; and the wetlands and savannas of the Lake Okeechobee Basin. Each of these groups—archaeologists call them cultures—also are identified with a specific assemblage of artifacts and other archaeologically recovered traits, especially styles of pottery.

In short, regional cultures developed with their own histories and lifeways. Building on the knowledge and experience of their Archaic ancestors, these societies were well acquainted with the technological, economic, and social skills which allowed people to flourish in their natural surroundings, whether those surroundings were the St. Johns River or Lake Okeechobee. Each culture also had a complex belief system, which allowed them to better understand and explain themselves and the world around them. Indeed, among pre-Columbian Floridians, religion and everyday life were so entwined as to be inseparable.

One problem in studying these regional cultures is what to call them. Archaeologists have no way of knowing what individual groups called themselves in their respective languages and dialects. (It may have been as simple as "Us." "We're us, we're the people; you, who are not of this same group, are the others"). As a consequence, archaeologists have assigned names to the regional cultures. Most often the names are taken from modern landmarks near where archaeological

excavations on a culture were first carried out. For instance, the St. Johns culture of northeast Florida takes its name from the St. Johns River where archaeologists in the nineteenth century recognized and excavated large shell heaps—middens (garbage deposits)—left behind by the pre-Columbian inhabitants. Likewise, the Belle Glade culture of the Lake Okeechobee Basin was named for the town of Belle Glade, Florida. Archaeologists carried out excavations in a mound near that town in the 1930s.

Another problem when dealing with Florida's regional cultures is there are not firm dividing lines between them. They tend to blend into one another, especially when we use artifacts such as pottery types to define those cultures. Archaeologists also give modern names to artifacts, including types of stone tools—especially points used to tip spears and arrows—and types of pottery. Arrow points from the region of the St. Johns culture, for example, are called Pinellas Points, so named for points of the same type found on the Pinellas Peninsula of Florida's Gulf coast on the west side of Tampa Bay where archaeologists first published descriptions of the points. Another is Glades Plain pottery, named for the Everglades where similar pottery was first recognized. All these names are necessary because we need labels for the people who once lived in Florida, as well as for the tools and other objects they used.

Even if we knew how each separate group of people within each culture referred to themselves, we would probably still have to make up names for the regional cultures. That's because there were just too many individual villages and groups of people within each culture. Literally, tens of thousands of them. But we do assign names to individual sites, many of which were individual towns hundreds of years ago. Sites, like cultures, are given the names of local landmarks or other modern designations, such as the names of landowners. On Amelia Island, for instance, I've been at the Harrison Homestead site, the Fernandina Cemetery site, the Old Fernandina site, and Walker Point Mound.

In Florida, each known site is also recorded in a state-operated file, where it is assigned a number and its location and characteristics are noted. Thus, the Harrison Homestead site on Amelia Island is site 8NA41, where 8 stands for Florida, NA for Nassau County, and 41 means the 41st site recorded in that county. Sites in every state, county, and parish in the United States are similarly numbered. Keeping files of sites is not only good for archaeologists who wish to study individual sites and regional cultures, it provides a valuable database for officials, developers, and agencies who wish to help preserve sites.

Florida's history, a commodity that enhances our ties to our state and our past, literally is all around us. Many people come to Florida every year to visit the state's natural areas, including archaeological sites.

St. Johns Culture

As noted above, northeast Florida, including the St. Johns River drainage from Brevard County north to Jacksonville, as well as the adjacent Atlantic coast, was the region of the St. Johns culture. The St. Johns culture people are the descendants of the Late Archaic populations who lived in the same region.

At various times, the northern and southern ends of the St. Johns culture saw the appearance of their own regional cultures. After about A.D. 1200 the St. Marys culture was located in northeastern Florida from the mouth of the St. Johns River north. Earlier, a variant of the St. Johns culture, which archaeologists called the Indian River culture, developed and persisted on and near the coast in modern Indian River County and parts of Brevard County. Like their ancestors, St. Johns people made their livelihood by fishing, hunting, and gathering shellfish, as well as by collecting a host of other wild foods, both plants and animals. They also maintained gardens or at least encouraged semi-wild plants, such as gourds, squashes, and seed-producing grasses, to grow around their homes. To feed, clothe, and shelter themselves the St. Johns Indians, like their neighbors throughout the state, used cane, bark, wood, stone, shell, bone, antler, sharks teeth, and fired clay to fashion tools, weapons, and containers. They wove vegetable fibers into cloth and baskets, as well as rope and twine. With weaving tools much like those of modern fishermen, string and twine were woven into nets and made into snares. Animal pelts were tanned and used for clothing and other purposes. Applying tried-and-true knowledge gained over millennia by all the Indians who had come before them, the St. Johns people, like other pre-Columbian Florida Indians, successfully understood and used the natural bounty around them.

The St. Johns people and other Florida Indians of the regional cultures lived in villages probably each of which numbered as many as several hundred people. Individuals belonged to a lineage or clan, most likely the clan of their mother. Each clan had its own distinctive paraphernalia and ceremonies, stories and legends, which helped to bond clan members together. The same clan would have been represented within many different villages, helping to create kinship ties among the people of those villages.

Because clan members had to marry someone from another clan, families within a village or among a cluster of villages were linked together by marriage ties. For instance, if a man of the Earth clan married a woman of the Wind clan and went to live with her in her village with her Wind clan relatives, he still would have retained his ties to his Earth clan, and his Wind clan in-laws may have been better disposed toward Earth clan members overall. All of these kinship and marriage ties served to cement relationships among villages and to create feelings of shared identity, especially among historically linked villages.

Villages were historically linked, because they may have shared a common ancestry. When one village grew too large for its inhabitants to easily feed themselves without having to hunt or collect food at long distances, members of one or more families (and clans) may have moved to a new location and founded a new village. Over time, any one locale may have had a group of linked villages, each budded off from another, older village.

Each village had leaders who helped the inhabitants reach consensus concerning village matters and who coordinated communal activities, such as religious ceremonies, seasonal fishing excursions, and other group endeavors. Individual families and clans might also have had elder leaders, and those individuals were the people who worked with village leaders to govern the social, economic, and religious life of the town.

All of the kin and village ties were reinforced by shared histories and traditions and by the performance of inter- and intra-village festivals and ceremonies. Clan ties were cemented through burial rituals and practices, especially the maintenance of clan charnel houses and burial mounds. When a member of the Earth clan died, that individual's body was placed in the Earth clan's charnel house with the remains of other clan members. Later, the cleaned bones or entire bodies of those clan members were afforded interment in a clan-maintained burial mound. Charnel houses and mounds were physical symbols of clan membership that crosscut generations. They were another means by which groups of Florida Indians assured a sense of shared being that in turn stimulated cooperative activities necessary for their livelihoods.

Trade was another phenomenon that tied communities together and provided economic benefits. Some traders may have trekked long distances, traveling by foot or canoe even to locations outside of Florida. Other trade may have been from village to village, allowing some goods to travel great distances. To obtain the goods, people went only

to the next town where trading might have taken place in conjunction with inter-village celebrations or festivals.

The evidence for such trade in northeast Florida and elsewhere in the state is widespread. Green stone and other exotic rocks and minerals from the Appalachian Mountains, as well as copper from the Great Lakes region, made their way to Florida, probably in trade for *Busycon* shells and the Yaupon holly leaves used to brew a ceremonial tea drunk from whelk shell cups. Many other items also were traded, including tools and ceramic vessels. Just as people today value non-local items, so did the Florida Indians want to acquire things that could not be found nearby.

After A.D. 750, some of the St. Johns peoples north of Lake George apparently began to grow corn and to place more emphasis on the gardening of other plants, such as squashes. Exactly when corn became an important element in the St. Johns people's diet is a topic of debate among archaeologists. There is some evidence that it was not until A.D. 1,000 that corn became a significant food source, while other plants were grown much earlier. But what is certain is that the St. Johns people, as well as their neighbors to the west in peninsular Florida, never relied on corn to feed themselves as heavily as did post-A.D. 1,000 Indian societies living in the eastern Florida Panhandle (the Fort Walton culture) or in the many river valleys of interior Georgia, Alabama, and other southeastern states.

One reason is that the soils of northeast and central Florida were not as fertile as the soils of the Tallahassee area or the river valleys of other southeastern states. The latter, replenished by yearly flooding, were especially well suited to intensive corn farming. Those of the St. Johns River drainage or the northeast Florida coast were not. Rather than becoming dependent on cultivated plants, the St. Johns people continued to rely heavily on the wild foodstuffs of their region, especially the fish, shellfish, and other animals and plants that were readily available in and around the many wetlands of northeast Florida.

Even so, planting and harvesting crops brought changes to St. Johns villages. Fields had to be divided among families, cleared, and prepared for planting; the best time to plant seeds needed to be determined; crops had to be weeded; corn and other harvested crops had to be divided among families and stored. Farmers had to worry about soil fertility, rainfall, animal pests, and the effect of climate and pests on their stored harvests. The roles of village leaders grew in importance and complexity as leaders coped with cooperative agricultural ventures.

Not only did the leaders need to coordinate their villagers and intercede among clans, they also had to exert influence with supernatural powers to determine planting cycles, bring rain, and assure a good harvest. They also had to protect stored harvests against the threat of raids by other Indians who wanted to take such wealth for themselves.

With at least a portion of the people's diet coming from farming, villages became larger, populations increased in number, and more social controls and coordination were needed. It became more difficult for villages to be governed by consensus, and authority figures, both civic and religious officials, assumed more power. As a result, among some of the St. Johns and other Florida Indian populations, social stratification increased; some clans became more important than others and gained higher status. Leaders became individuals who inherited their offices because of their membership in higher ranked clans. Such a new social and political system, not to mention the agricultural activities, led to new beliefs and ceremonies. In short, individual native societies became more complex as these new cultural institutions evolved and took hold.

Village leaders were replaced by hereditary chiefs and religious figures, who maintained control over their people. Such leaders also provided a bridge between villagers and the supernatural. The special status of chiefly officials and the lineages and clans to which they belonged was signaled by their wearing and possessing special paraphernalia and iconography, symbols of their status, power, and wealth. Exotic objects acquired through trade and the symbols of status were the possessions of chiefs who could distribute them to their subjects as rewards for obedience and allegiance. Chiefs could claim a share of each harvest, as well as portions of other foodstuffs, signs of homage paid them by their subjects. Chiefs also could demand that villagers offer labor as a form of tribute. Using such labor, mounds were built to house the tombs of deceased members of chiefly families; sometimes chiefly officials lived in houses built atop such mounds.

Some chiefs grew especially powerful in wealth and importance, thanks to personal skills, but also due to the economic efforts of their villages. As villages budded off, chiefs of parent villages might be ranked above the chiefs of the new villages, who were subservient. Chiefs also sought to extend their power to other villages and groups of villages. Political alliances were made through marriage into elite families and by other means. Sometimes military force was used or threatened as a way to extend a chief's dominance.

Chiefs not only had power, they also had obligations. They needed to assure that their villagers prospered; that crops and wild foods were available and distributed as needed; and they needed to help see to the spiritual well being of their people. Rare was the chief who did not seek counsel from village elders and other influential individuals.

In northeast Florida after A.D. 1,000, the presence of chiefdoms—as archaeologists have named these complex political entities—is reflected in the appearance, at a limited number of St. Johns culture villages, of large sand mounds that served as the bases for chiefly buildings and which often contain a host of high-status paraphernalia, sometimes made of exotic substances. Many copper items, for instance, have been recovered from the large mound at the Mount Royal site just north of Lake George in Putnam County.

Though there may have been only a limited number of powerful, paramount chiefs who headed alliances and had other chiefs as vassals, lesser chiefs mimicked those of elevated status by adopting the trappings of power, such as being transported in litters carried by loyal subjects.

Across northeast Florida, chiefdoms became the norm. Even so, paramount chiefs, lesser chiefs, and chiefly alliances came and went as chiefs, high ranked clans, and villages rose and fell with the tide of military and economic fortunes.

By the time the French and then the Spanish reached northeast Florida in the 1560s, chiefdoms dotted the St. Johns region. French and Spanish leaders interacted firsthand with many native village chiefs, including several paramount chiefs living along and near the mouth of the St. Johns River—leaders of the various Timucuan Indian societies who lived in those regions in the colonial period. As we shall see in chapter 4, we know a great deal about the Timucua. What is perhaps most extraordinary is that many of the Timucua were the descendants of the earliest St. Johns culture people. When the French and Spaniards arrived and met Timucua chiefs, they were meeting leaders whose ancestors had lived in the same localities for hundreds and even thousands of years.

Deptford Culture

In addition to the St. Johns culture, archaeologists recognize other post-500 B.C. regional cultures in the state. One is the Deptford culture, which is contemporary with the early portion of the St. Johns

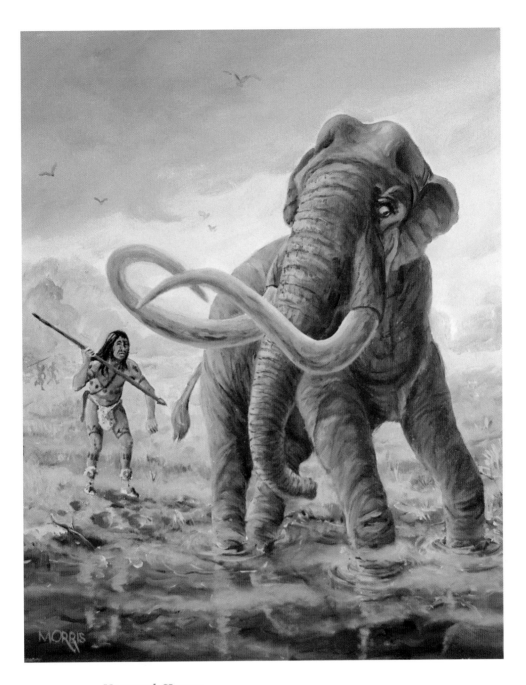

Mammoth Hunter

A cautious hunter stalks a Florida mammoth mired in the mud at the edge of a watering hole. The hunter takes advantage of this unique opportunity to get in close enough to use his large spear. In this painting, I use intense, contrasting color to dramatize the life and death struggle to come. (Artifacts and objects: wood spear with stone point; deerskin strap and storage pouch; body paint; deerskin breechcloth and footwear; Columbian mammoth. Paleoindian culture.)

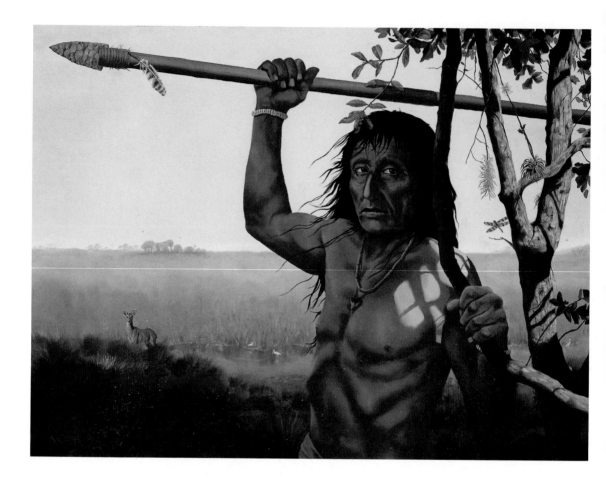

Early Florida Hunter

One hunter signals another as he tracks a deer through marshy grasslands. Used for food and clothing, deer and other game were also traded among tribes. By emphasizing the hunter's poise and by selecting a palette of earth tones, I try to demonstrate these early people's oneness with nature. I want the viewer to sense the respect this quiet hunter gives his prey. His stalwart expression reveals that he will complete the task before him. (Artifacts and objects: shell bead bracelets; shark-tooth pendant; spear point made from chert; hawk feather. Archaic culture.)

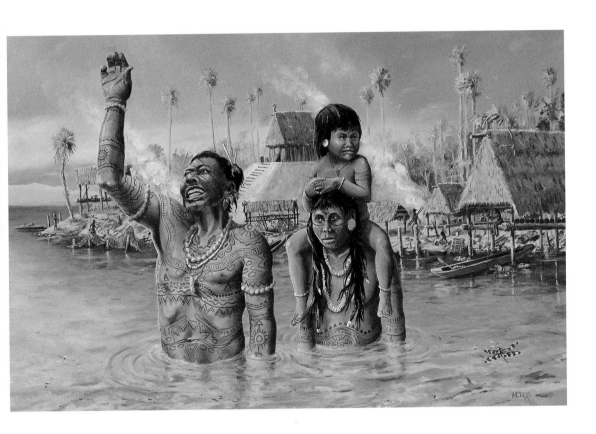

The Traders (Unknown tribe)

Here, I depict an Indian family from interior Florida leaving a coastal village. They have just traded alligator and otter skins for shell beads. From coast to coast, tribes traded with each other and also exchanged ideas at their meetings. For artifacts, I show many common articles of trade, and for my background, a typical village scene. (Artifacts and objects: shell and shark-tooth ear decorations; shell bead bracelets, armbands, necklaces, and ankle bracelets; shell pendant; bone hairpins; body tattoos; blue jay feathers; dragonfly.)

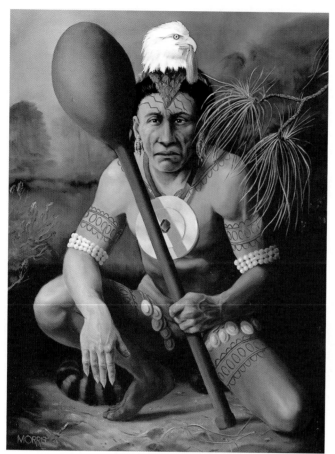

Eagle War Chief (Timucua tribe)

This fierce warrior contemplates battle. His alert pose suggests the tension of war preparations. The distinctive eagle headdress, brutal war club, pearl beads, and shiny copper ornaments indicate his status as a war leader. Raccoon tails attached to the back of his breechcloth exemplify the high value ancients placed on all animals. The unusual turkey-foot ear ornaments are depicted in one of de Bry's engravings. They also are mentioned by early European travelers in Virginia and the Carolinas. (Artifacts and objects: eagle headdress with tassel; turkey-foot ear decorations; hardwood war club; copper chest plate; shell and pearl bead armbands; deerskin breechcloth with raccoon tails. St. Johns culture.)

Child with Scrub Jay (Ocale tribe)

This painting portrays a happy child feeding a friendly scrub jay. Her face conveys her joy as the bird perches on her hand in the early morning mist that enshrouds the ancient scrub. At one time abundant in Florida, scrub jays have no fear of humans. Today this threatened species is seldom seen due to destruction of its habitat. (Artifacts and objects: shell bead bracelet. Variant of Safety Harbor culture.)

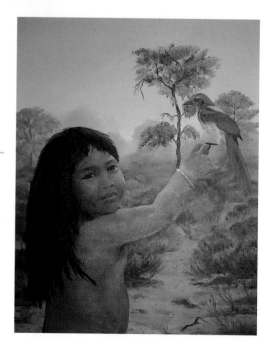

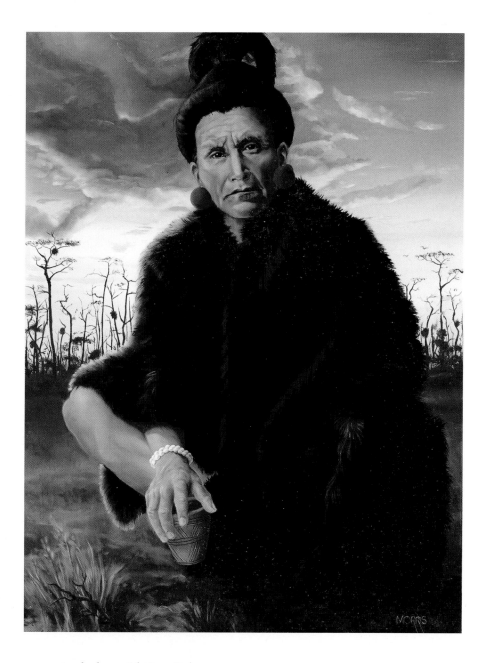

Apalachee with Bear Robe

A man sits bundled against a cold north Florida winter's dawn. His robe is made from the hide of the Florida black bear. By silhouetting dark cypress against a colorful sky, I tried to capture the sharp, bright chill characteristic of Florida's winter mornings. (Artifacts and objects: fish-bladder ear decorations; carved shell bead bracelet; incised clay pottery cup. Fort Walton culture. Collection of Millie and Phil Heveran.)

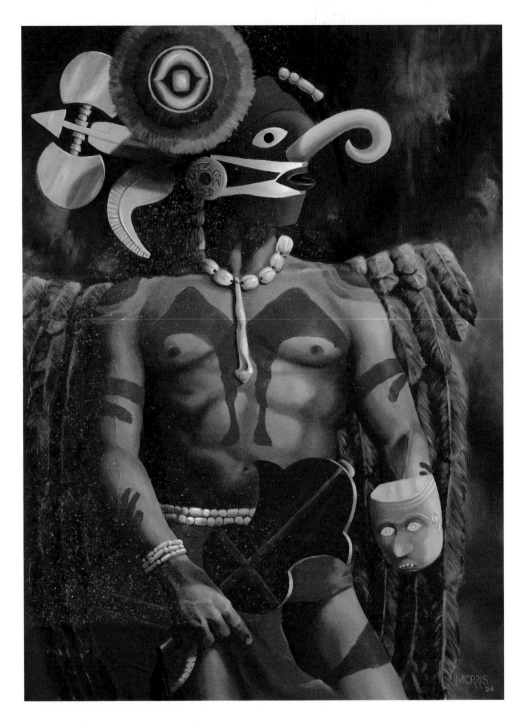

Bird Man Dancer (Apalachee tribe)

As in other Native American tribes, birds held a potent spiritual meaning for the Apalachee people. The superbly crafted ornaments the dancer wears symbolize courage, honor, and tradition. This is the first painting I did of the lost tribes. (Artifacts and objects: body paint; feathered circle with copper insert; carved and painted wood mask with copper attachments; shell hair beads; queen conch shell beads; whelk shell pendant; shell bead bracelet and belt; carved wood baton with human hair on handle; rattles [carved wood covered with a thin layer of copper]; painted deerskin breechcloth. Fort Walton culture.)

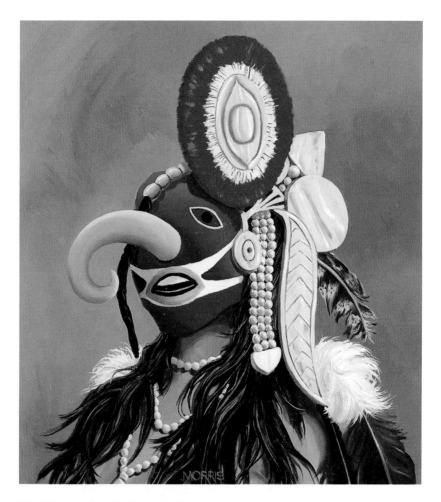

Bird Woman (Apalachee tribe)

With its beautifully crafted copper attachments and feathered circle, this colorfully painted wood mask is powerful and expressive. I based this mask on an engraved copper breastplate found with a woman buried in one of the mounds at the Lake Jackson site near Tallahassee. By painting only the top of the costume, I emphasize the complexity of a culture reflected in its elaborate ornaments. (Artifacts and objects: feathered circle with copper insert; copper attachments; blue jay and hawk feathers; shell beads; carved and painted wood mask; pearl necklaces; feathered cape. Fort Walton culture.)

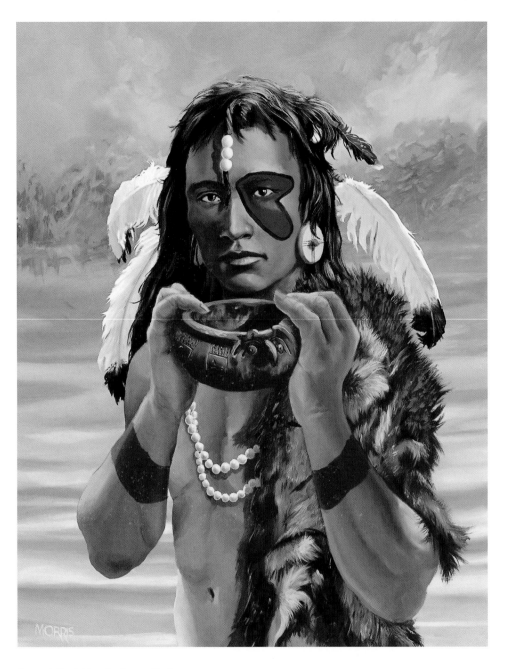

Sacred Owl (Apalachee tribe)

The Apalachee divided their universe into three worlds: the under world of ghosts and monsters; this world of the native peoples; and the upper world of special beings, such as sun and moon. As flying creatures, birds were often associated with the upper world. A nighttime bird of prey, the owl may have had a special significance as a mediator between worlds. In this painting, the priest's face paint and beaded forelock are based on an engraved copper plate found in a mound at the Lake Jackson site near Tallahassee, Florida. I eliminated background detail in order to concentrate viewer attention on the person and to create an otherworldly atmosphere. (Artifacts and objects: blue jay and eagle feathers; shell hair beads; copper ear decorations; body paint; owl effigy ceramic bowl; deer hide; pearl beads. Fort Walton culture.)

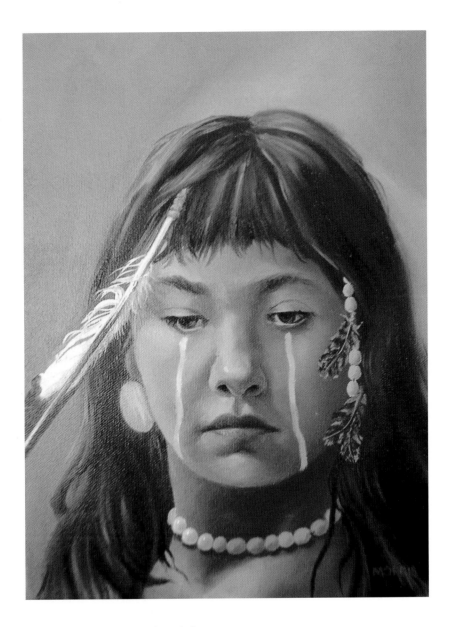

Tribal Woman (Pensacola tribe)

Pensacola tribeswomen were described by the Spanish as having long hair and painted bodies. In this painting, I tried to portray womanly tenderness and confidence. (Artifacts and objects: seagull feather; shell beads with turkey feathers; face paint; pearl necklace. Fort Walton/Pensacola culture. Private collection.)

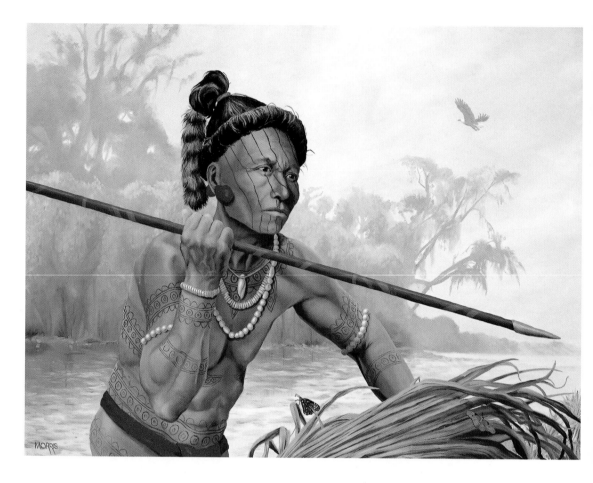

Morning Hunt (Tocobaga tribe)

In the misty morning hours, a Tocobaga tribesman stalks his prey on the shore of Tampa Bay. He must be wary of neighboring warring tribes. The intricate tattoos on his body indicate he is a leader among his people. I use a faded background to evoke the serenity of early morning. While balancing the composition, a bristling palmetto frond in the foreground suggests motion and action. (Artifacts and objects: raccoon tail; fish-bladder ear decorations; body tattoos; wood spear with bone tip; shell bead necklace; shell pendant; shell bead bracelet; bald eagle; monarch and Julia butterflies. Safety Harbor culture.)

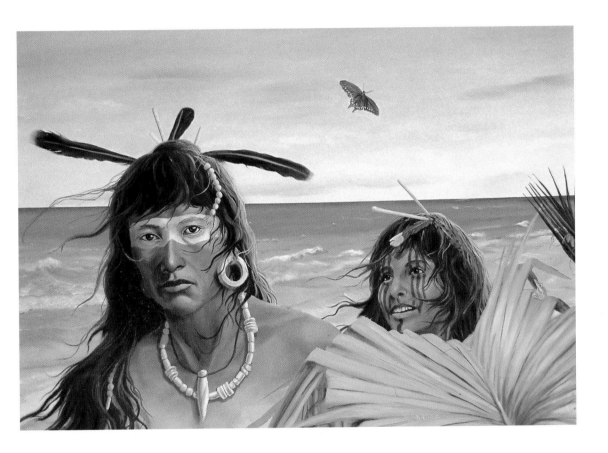

The Teacher (Tocobaga tribe)

As in all cultures, the young learn how to survive in the world from adults. The teacher looks out at us as if waiting for a question. Placed, by implication, in a questioning position, viewers may sense they have much to learn from this Indian teacher. (Artifacts and objects: pipe vine swallowtail butterfly; cormorant feathers; shell ear decorations; shell pendant; shell bead necklace; bone hairpins. Safety Harbor culture. Private collection.)

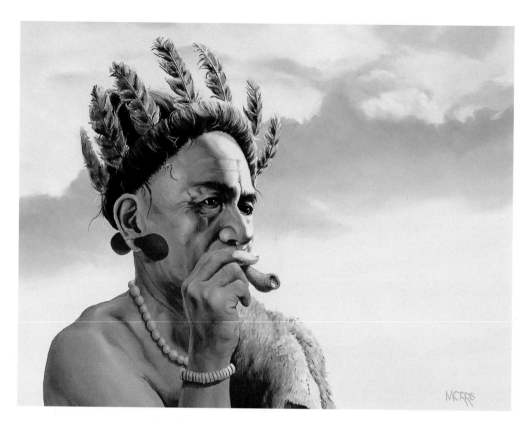

Sacred Pipe (Tocobaga tribe)

Here, lowering, pregnant clouds evoke the mystical aura surrounding a Tocobaga tribesman as he smokes a sacred pipe. Tobacco and other plants were smoked on ceremonial occasions. The tribesman's deer hide reflects a life lived close to nature and its creatures. (Artifacts and objects: turkey feathers; fish-bladder ear decorations; ceramic pipe; shell bead necklace and bracelet; deer hide. Safety Harbor culture. Collection of Rob and Andi Blount.)

Cypress Hunt (Tocobaga tribe)

A Tocobaga tribesman hunts sleepy birds in this cathedral-like setting near present-day Tampa. In the late afternoon light, fog swirls around the hunter, helping to hide him from his prey. In this painting, I wanted to depict Florida's natural beauty and man's place in it. (Artifacts and objects: bow and arrow; white ibis. Safety Harbor culture. Collection of John and Mary Gunther.)

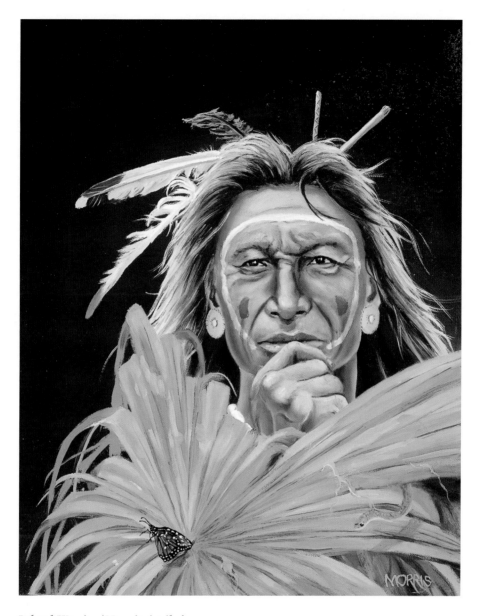

Inland Warrior (Mayaimi tribe)

The Mayaimi were subjects of Carlos, chief of the Calusa tribe, and paid him tribute in food, animal skins, root tubers, and other goods. The dark background focuses our attention on the old warrior, who grips us with his direct gaze. His face paint may hold magical powers, passed down to him over many generations. In this work, I try to capture in the warrior's face some of the intensity, reserve, pride, and anxiety that may have been experienced by tribesmen forced into subservience. (Artifacts and objects: bone hairpins; turkey and seagull feathers; face paint; copper-covered wood ear ornaments; shell beads; green tree snake; monarch butterfly. Belle Glade culture.)

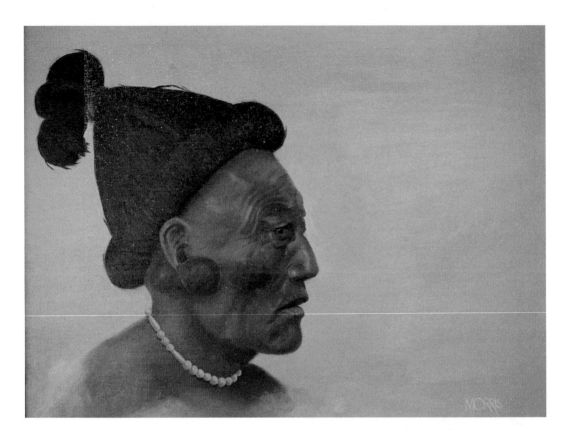

Potano Male

In 1539, the de Soto expedition encountered the Potano near present-day Gainesville. Here, I imagine how a tribesman might have looked when the Spanish first saw this people. By using a limited pallet of colors, I emphasize the man's interesting facial structure. (Artifacts and objects: fish-bladder ear decorations; shell bead necklace. Alachua culture. Private collection.)

Into the Light (Mayaimi tribe)

An ancient tribesman walks through a corridor of green foliage. Colorful European glass trade beads hang from his neck, and an exquisitely designed silver woodpecker hair ornament projects from his hair. Processed from earth's ore, the silver pendant symbolically connects its wearer to his earthly world. In this work, I try to intensify the canopy's lush vegetation by painting the play of light and shadow across the man's body. (Artifacts and objects: silver hair ornament; fish-bladder ear decorations; European glass beads; silver pendant; painted deerskin breechcloth. Belle Glade culture.)

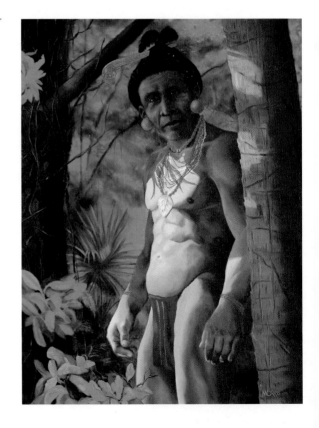

Nature's Bounty (Jeaga tribe)

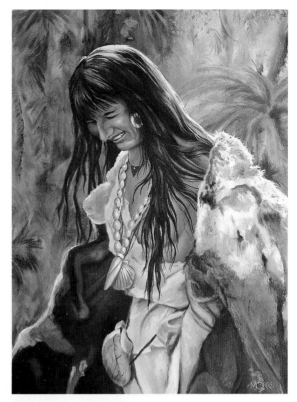

This Jeaga maiden covers herself with a robe made from deer pelts. Deer were a plentiful and very important source of food, clothing, shoes, bowstrings, bindings, and other useful items. From deer bones and antlers, native peoples fashioned spear points, eating utensils, fishhooks, beads, and many kinds of tools. By emphasizing the woman's vibrant, joyful expression, I invite the viewer to appreciate her unique humanity—something I try to do in all of my paintings. (Artifacts and objects: shell and wood ear decorations; deer pelt robe; shell bead necklace; deerskin dress; shell pendant; scallop shell gorget; turtle shell purse. East Okeechobee/Glades variant culture.)

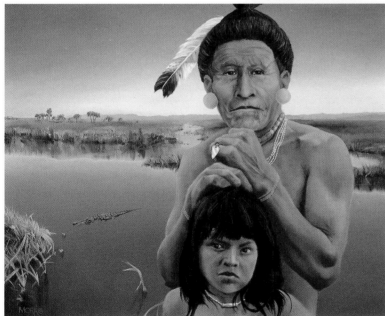

Legacy (Mayaimi tribe)

A wise grandfather teaches his granddaughter about the Mayaimi tribe's rich heritage and wonders what the future will bring. He has traded with neighboring tribes for his European beads and has heard about the new diseases killing many of their people. I placed both the old man and child in the marshy land north of Lake Okeechobee to show their regional connection to this wetland. (Artifacts and objects: eagle feather; blue glass beads; colored glass seed beads; silver pendants. Belle Glade culture. Collection of Archaeological Consultants, Inc., Sarasota, Florida.)

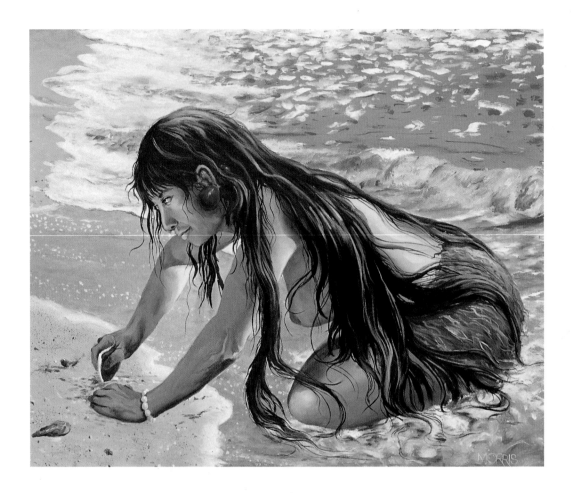

Gathering Coquina (Jeaga tribe)

This Jeaga maiden gathers coquinas to boil for a tasty broth. Coquinas are brightly colored bivalves that live in the surf-pounded tidal zones of beaches. Their shells comprise a large part of some of the shell mounds on Florida's east coast and along the St. Johns River. The bright coquinas contrast with the darkly sparkling water, while the woman's flowing hair mimics the motion of the waves. (Artifacts and objects: painted fish-bladder ear decorations; Spanish moss skirt; carved shell bead bracelet. East Okeechobee/Glades variant culture.)

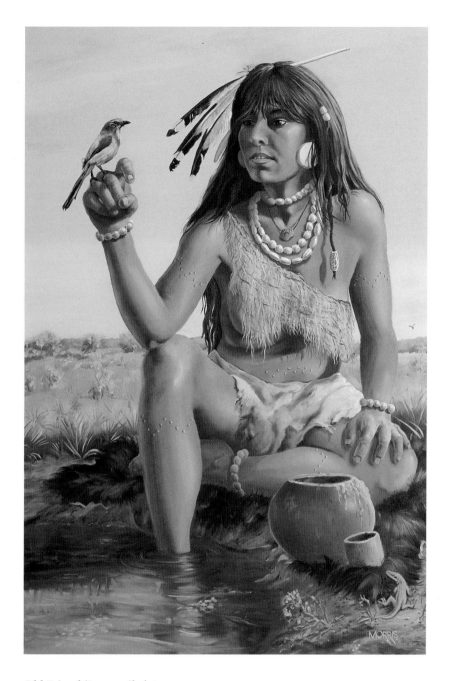

Old Friend (Jeaga tribe)

A Jeaga maiden greets a familiar Florida scrub jay. Both their worlds encompass only a few miles. Like the members of a tribe, scrub jays live in families of up to eight birds. They cooperatively gather food, watch for enemies, and even feed babies. Highlighting the close connection between Florida Indians and their environment, I combine harmonious colors to suggest the ties between people and the creatures with which they share their world. (Artifacts and objects: bone hairpin; seagull feathers; gold ear decorations; shell beads; **Oliva** *shell hair decorations; Spanish moss covering; deerskin skirt; bear skin; ceramic pots; green anole lizard. East Okeechobee/Glades variant culture.)*

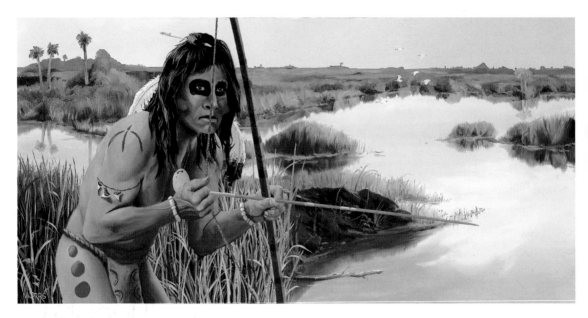

Everglades Hunt (Tequesta tribe)

As dawn breaks, a hunter stalks prey in the bountiful Everglades. The hardwood hammocks disappear over the horizon like a distant flotilla. Although we have no accurate description of the Tequesta's personal adornments, bone and shell artifacts have been found in their territory. I depict the hunter with raccoon's eyes, bird's feet on his shoulders, and circles or bubbles on his legs to represent aquatic life. While I was able to pattern his loincloth markings on actual pottery designs, I had to imagine how he might have used body paint to invoke the power of the animals he hunted. (Artifacts and objects: carved bone hairpin; body paint; hunting bow and arrow; shell gorget; shark-tooth armband; shell wrist beads; buckskin loincloth. Glades culture.)

Woman of the Sacred Clay (Tequesta tribe)

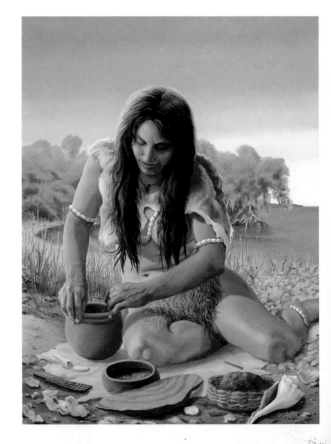

In her native coastal surroundings, a Tequesta woman uses the coil method to make pottery. After they were shaped and their designs impressed, the clay pots were baked in an open fire. Whether or not early people revered the clay before it was fired remains unknown. They certainly considered sacred the ceremonial vessels used in funerary and other religious rites. (Artifacts and objects: deer pelt; shark-tooth pendant; shell bead necklace, armbands, and ankle band; Spanish moss skirt; deerskin ground covering. Glades culture.)

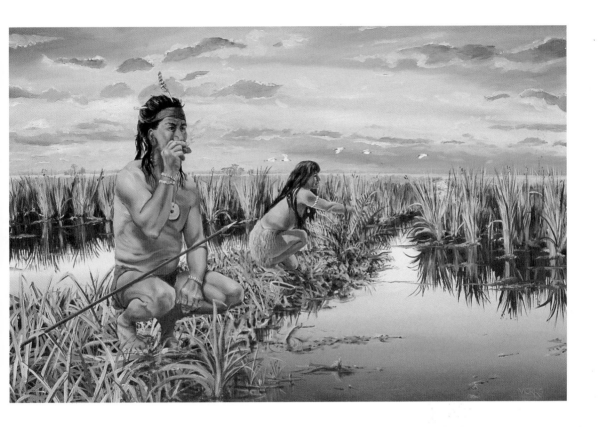

Smoke in the Wind (Tequesta tribe)

Surrounded by the Everglades' rich ecosystem, a Tequesta hunter smokes his pipe as his wife examines a coontie plant. The edible root of this plant provided the Tequesta and other tribes with a valuable starch source. In this painting, I subordinate the human figures to the luminous beauty of the Tequesta's watery world. (Artifacts and objects: snowy egrets; shell beads and pendant; Spanish moss skirt; turkey feather; carved bone hairpins; painted buckskin head wrap and loincloth; wood ear decorations; carved stone pipe; shell beads and gorget; fish and bird spear with bone point; painted buckskin loincloth. Glades culture.)

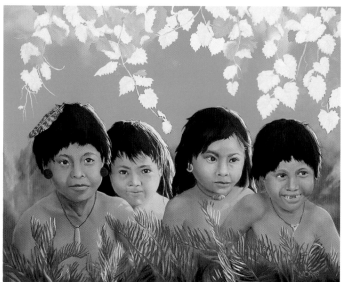

Under the Canopy (Calusa tribe)

The children in this portrait represent all children throughout history. Cousins between the ages of four and seven, they have been playing in the woods under the canopy of wild muscadine and among the coonties' stiff fronds. Each child in this painting has his or her own distinct personality, and all wear a piece of jewelry chosen by their mothers. This painting reminds me of my own childhood: my brother and I loved nothing better than to run and play freely through the woods near our home. (Artifacts and objects: Oliva shell beads; shell ear decoration with wood inlay; shark-tooth pendant; stone pendant; coontie plants; muscadine grapevines. Caloosahatchee culture. Collection of Justyna Clipper.)

Morning Offertory (Calusa tribe)

On top of a high mound, a priest offers black drink to the sun. The ancient ones believed that three gods ruled the cosmos: the greatest, most powerful god controlled weather, sun, moon, and stars; the next most powerful god ruled all kingdoms; and the third, the god of war, intervened for those who sought his help. The carved wood masks and box, along with the palmetto berries in the ceramic bowl, will be used in the ritual. Perhaps the offering will bring the Calusa the great strength they need as they prepare for the battles and many changes to come. (Artifacts and objects: sharp-shinned hawk; body paint; pheasant feathers; pearl neck-lace; carved shell necklace; wood bowl; Oliva shell bracelets; pelican feather armband; carved and painted wood masks; wood box; ceramic bowl. Caloosahatchee culture.)

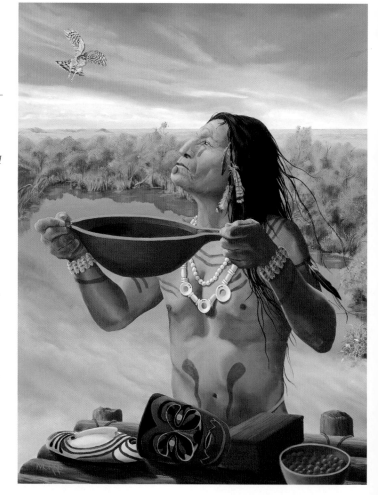

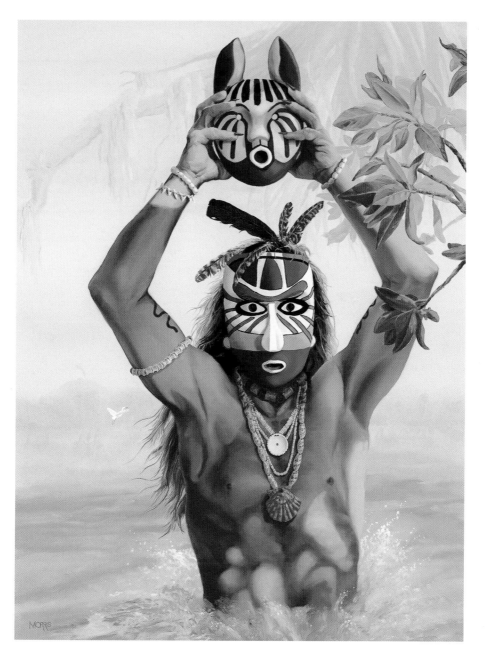

Ceremonial Secrets at Mound Key (Calusa tribe)

After descending the temple mound, a Calusa high priest prepares himself for a secret ceremony, perhaps a ritual ensuring a plentiful sea harvest. Shellfish and other sea foods were mainstays of the Calusa diet. The mask designs are taken from actual masks excavated at the Key Marco site in Collier County, Florida, by Frank Hamilton Cushing during the Pepper-Hearst Expedition in 1896. Undisturbed for many centuries and preserved by the muck at Key Marco, these masks have contributed to our knowledge of the Calusa. In this painting, I try to evoke the aura of mystical, sacred, and compelling power principal Calusa men were thought to possess. (Artifacts and objects: carved and painted wood masks; assorted bird feathers; shell bead bracelets; shark-tooth bracelet; shell beads with carved shell pendant; ceremonial body paint; animal vertebrae armband; carved bone and bead necklace; Oliva shell bead necklace with cat's paw shell pendant. Caloosahatchee culture. Collection of Justyna Clipper.)

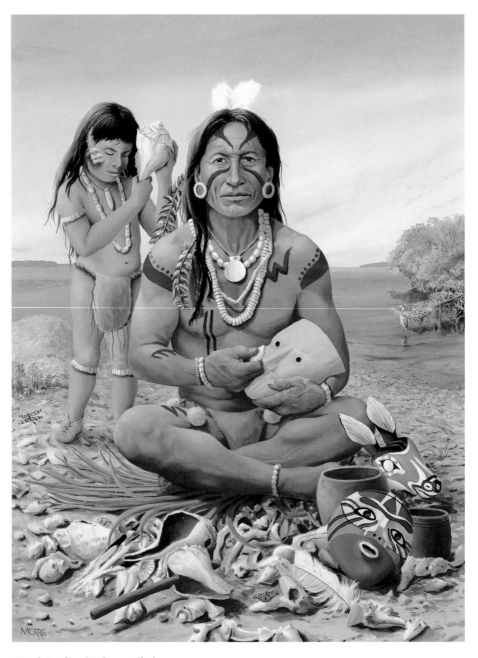

Mask Maker (Calusa tribe)

On the shore at Mound Key in Estero Bay, just south of Fort Myers, a man suddenly looks up from carving a ceremonial mask to confront the viewer. The surrounding artifacts show how intimately the Calusa lived with nature. This painting became the centerpiece in a 1998 video about Florida's early peoples. Produced by the Florida Anthropological Society and the Florida Department of State, it teaches the public about Florida's rich history. (Artifacts and objects: man—egret plumes; shell-and-wood ear decorations; carved whelk shell pendant; shell and bone bead bracelets; turkey feathers; shell and pearl bead bracelets; tassels made from cottonwood tree fibers; buckskin loincloth; pearl ankle beads; child—turkey feather; whelk shell pendant; Oliva shell necklace; shell bead arm and leg bands; buckskin attached to rope belt; foreground—carved and painted wood deer head and mask; ceramic pot; carved wood container; hammer made from lightning whelk. Caloosahatchee culture. Collection of Archaeological Consultants, Inc., Sarasota, Florida.)

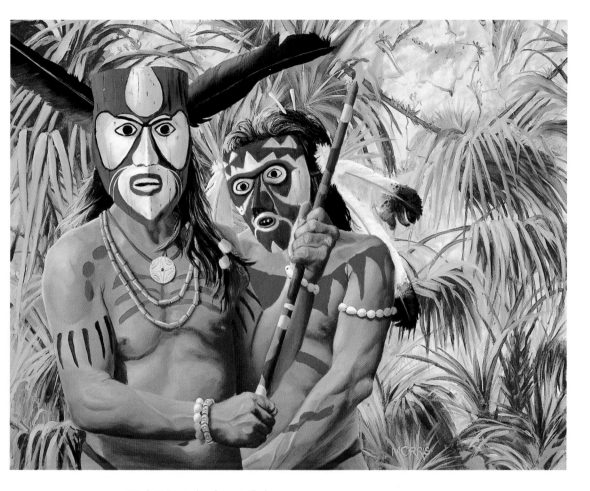

High Priests (Calusa tribe)

In 1567, a Spanish Jesuit called the Calusa priests' masks "horrible," and revealed that they were "kept in a temple built on top of a special mound." Although masks played an important role in Calusa culture, their exact purpose is unknown. In this painting, the priests' colorful, gruesome masks contrast sharply with the lush, subtropical vegetation enveloping them. (Artifacts and objects: left figure— cormorant feathers; carved and painted wood mask; silver pendant; copper bead necklace; shell hair beads; body paint; shell and bone bead bracelets; right figure— eagle feathers; bone hairpins; carved and painted wood mask; shell bead armband; body paint. Caloosahatchee culture.)

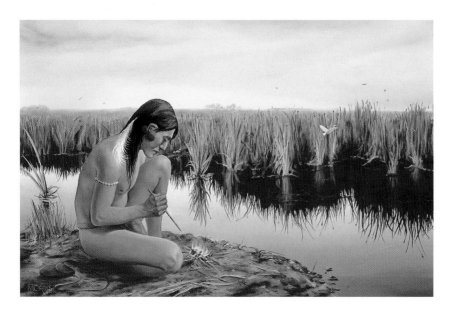

Afternoon Rain (Tequesta tribe)

As his ancestors have done for thousands of years, a Tequesta tribesman prepares a fire for his evening meal at the edge of the Everglades. By rendering light's refraction through a moisture-laden afternoon sky, I create a serene mood to evoke the solitude of early people and their reverence for the natural forces of daily life. (Artifacts and objects: egret feather; shell bead armband; deerskin loincloth; fish-bladder ear decoration. Glades culture. Collection of Neil and Ann Ketzlick.)

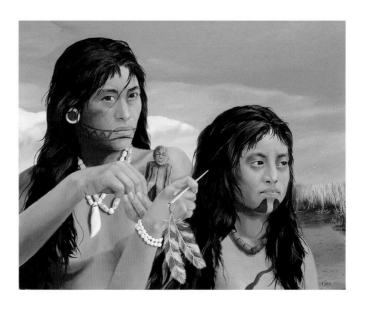

Calusa Girls

Following a warm, summer rain, two sisters—daughters of royalty—prepare for a tribal ceremony on Florida's lower west coast. The older girl holds a wood figurine, which may have religious significance, while the younger girl plays with her sister's bone hairpin adorned with hawk feathers. The vivid, overcast gray sky creates a dramatic backdrop that seems to anticipate the coming ceremony. (Artifacts and objects: shell-and-wood ear ornament; facial tattoos; shell bead necklace with carved whelk shell pendant; Oliva shell necklace; carved bone bead necklace; carved bone hairpin with hawk feathers; pearl bracelet; carved wooden figurine. Caloosahatchee culture.)

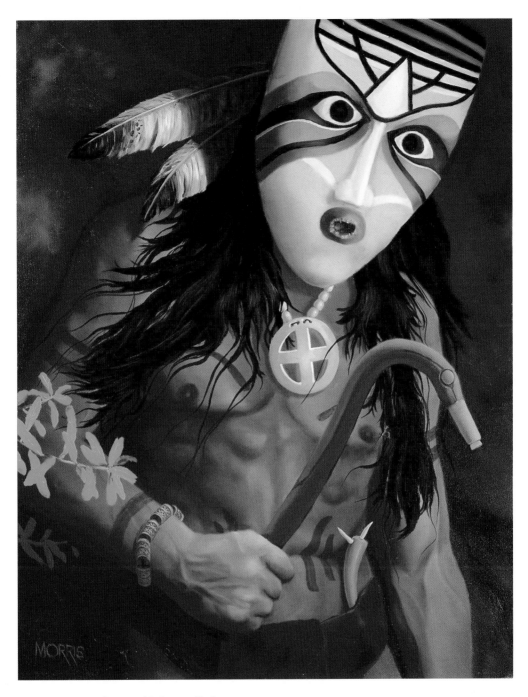

Shaman (Calusa tribe)

Intermediary between the human and spirit worlds, the shaman is considered essential to the tribe's survival. The dynamic carved and painted wood mask shown here was found at the Key Marco site. (Artifacts and objects: carved and painted wood mask; shell bead necklace; carved Busycon shell circular gorget; carved bone bracelet; hardwood adz handle with inserted deer antler and carved shell; deer antler knife with animal teeth; deerskin breechcloth. Caloosahatchee culture.)

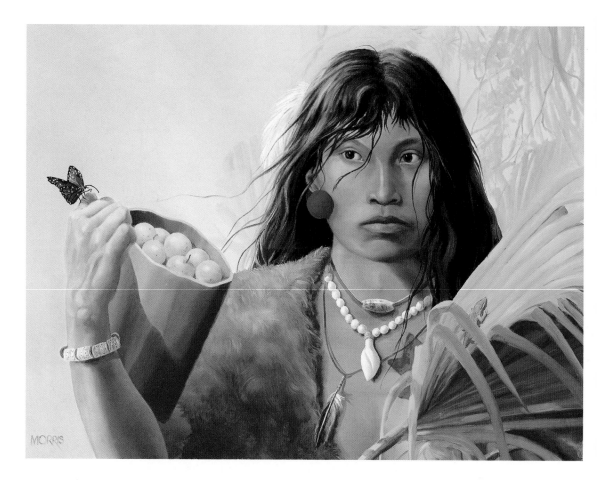

Preparations for the Feast (Calusa tribe)

A young Calusa woman prepares for a feast by gathering hog plums in a wooden tub. The Calusa lifestyle was leisurely. They enjoyed numerous celebrations and feasts, many of which were connected to religious ceremonies. I wanted to show this woman, going about her daily chores, at peace with herself and the world. Her enduring native beauty lies within her. (Artifacts and objects: egret plume; tub made from cypress tree trunk; hog plums; carved bone bracelet; fish-bladder ear decorations; Oliva shell necklace; carved shell pendant attached to pearl beads; body paint; pelican feather necklace; deerskin robe. Caloosahatchee culture.)

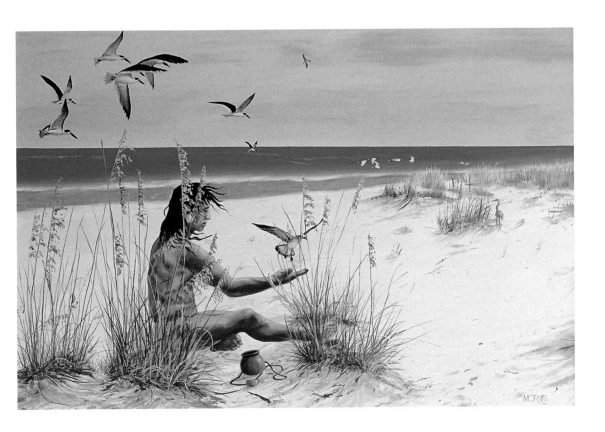

Connection (Calusa tribe)

The Calusa believed that when they died, two of their three souls entered into animal bodies. Here, a quiet communion between tribesman and seabird points to that spiritual bond. By diminishing the human figure in relation to the bright, expansive dunes, I try to show the Indian's humility before nature and to suggest the confluence of here and hereafter. (Artifacts and objects: black skimmer birds; copper ear spool; shell bead bracelet; ceramic bowl. Caloosahatchee culture. Collection of Justyna Clipper.)

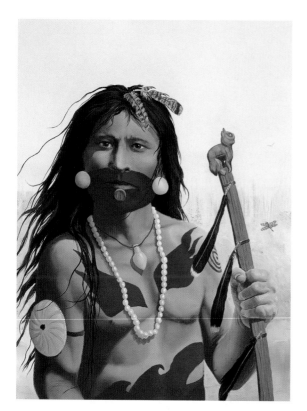

Spirit of the Fires (Calusa tribe)

Fire was vital to early Indian life. In addition to its ordinary utility, fire was considered magical and figured prominently in rituals and ceremonies. It was also used in the hunt as seventeenth-century Franciscan missionary Father Escobedo explained: the "lighting of piles of grass" was used "to hunt rabbits." In this work, the hunter's body paint evokes the power of fire: red flames span his chest and a glowing red dye stains his face. His gaze is intense and determined. He grips an atlatl (spear-thrower) with a rabbit carving on top. To use this device, a hunter first aligned the base of his spear with a groove atop the atlatl. The atlatl's thrust projected the spear farther and faster than one thrown by hand. (Artifacts and objects: pheasant and turkey feathers; fish-bladder ear decorations; wood labet inserted under lip; body paint; carved stone pendant; pearl necklace; silver and copper alloy metal disc; atlatl with rabbit carving. Caloosahatchee culture.)

Hunter (Tocobaga tribe)

A wary hunter pauses as he silently moves through the lush Florida landscape. An Indian bow was powerful enough to propel arrows through Spanish chain mail, yet it was unable to ward off the onslaught European diseases. Here, as in many of my paintings, the subject looks directly at the viewer. Through this device, I hope to make the modern viewer aware that he shares with early man a connection to the same land both have walked, a land today called Florida. (Artifacts and objects: calico scallop shell on forehead; bow and arrows; body tattoos; shell bead armband; pottery vessel. Safety Harbor culture. Collection of Justyna Clipper.)

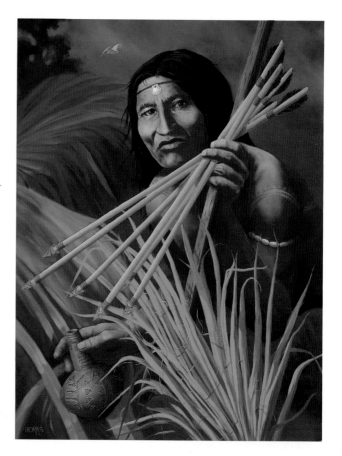

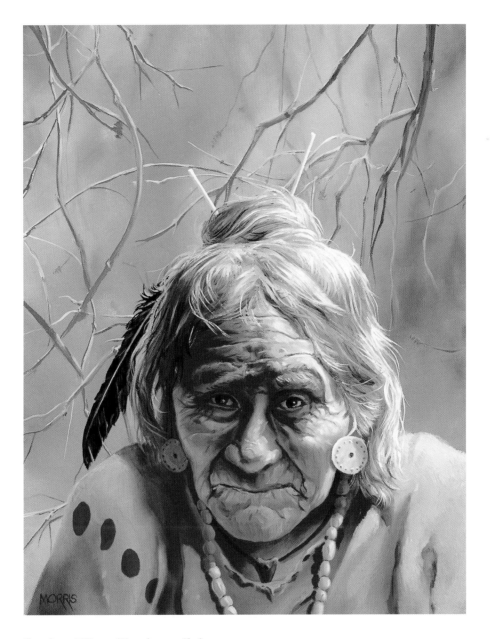

Tocobaga Winter (Tocobaga tribe)

Age may slow him down, but it does not diminish his determination or pride. The old man wonders how his tribe will survive after European diseases have decimated his people. I chose a vulture feather and painted dead, brittle wild grapevines in the background to reinforce the theme of death and ruin that troubles him. (Artifacts and objects: vulture feather; carved bone hairpins; copper ear spools; painted buckskin shirt; shell bead necklace. Safety Harbor culture. Collection of Justyna Clipper.)

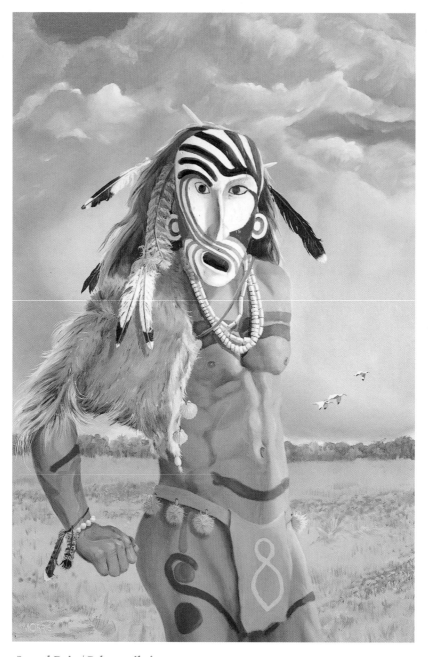

Sacred Rain (Calusa tribe)

The highest god of the Calusa cosmos controlled the brilliant beings: the sun, moon, and stars. Elaborate carved wood masks were part of Calusa religious pageantry. To emphasize the shaman's strength and connection to the powers of radiance, I place him in bright sunlight in contrast to the dark squall line approaching. (Artifacts and objects: bone hairpins; carved and painted wood mask; seagull, cormorant, and hawk feathers; shell-and-wood ear ornaments; bone necklace and shell bead necklace; deer hide; body paint [made from crushed red berries and from powdered galena, a silver-colored lead ore traded from Missouri mines]; painted shells; buckskin loincloth; tassels made from finely spun, dyed cords of cottonwood tree down; blue jay and pheasant feathers, pearl bracelet; white ibis. Caloosahatchee culture.)

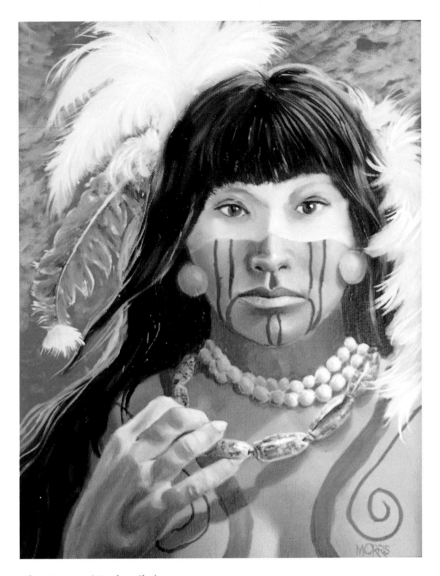

The Consort (Ocale tribe)

As they moved north from Tampa Bay, Hernando de Soto and his army terrorized the Ocale tribe. Some of his men took consorts from among the young women. In this work, bright colors emphasize the woman's youth and vitality. She will probably be dead from a European disease before her next birthday. (Artifacts and objects: egret plumes; turkey feather; fish-bladder ear decoration; shell bead necklace; Oliva shell bead necklace; body tattoos and paint. Variant of Safety Harbor culture.)

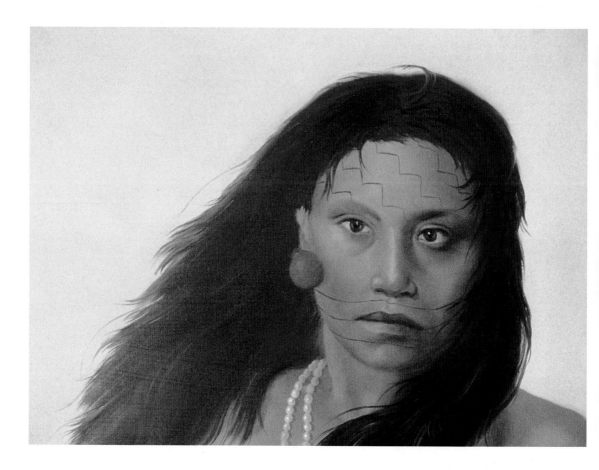

Potano Queen

When a Potano king was ready to take a wife, he ordered his principal men to bring him their daughters. The tallest and most beautiful was then chosen. In depicting this queen, I tried to capture the inner strength that was surely required to maintain her royal position. (Artifacts and objects: painted fish-bladder ear decorations; shell bead necklace; facial tattoos. Alachua culture. Private collection.)

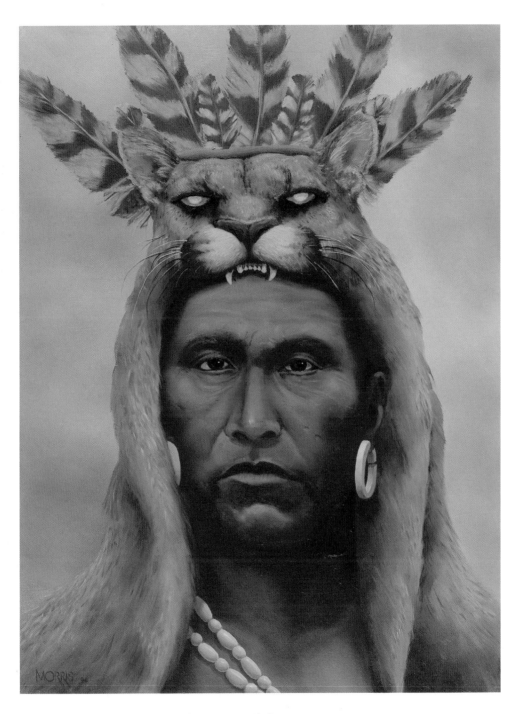

Panther Warrior (Timucua tribe)

Stoic and proud, a Saturiwa Indian warrior wears the panther headdress symbolic of high military rank. Made of highly polished shell, the panther's "eyes" reflect light to give the headdress a formidable dynamism like that of the living animal. In this painting, headdress and rich earth tones imply a direct connection between animal and man. (Artifacts and objects: panther skin headdress with hawk feathers; carved shell ear decorations; shell and pearl beads. St. Marys culture. Private collection.)

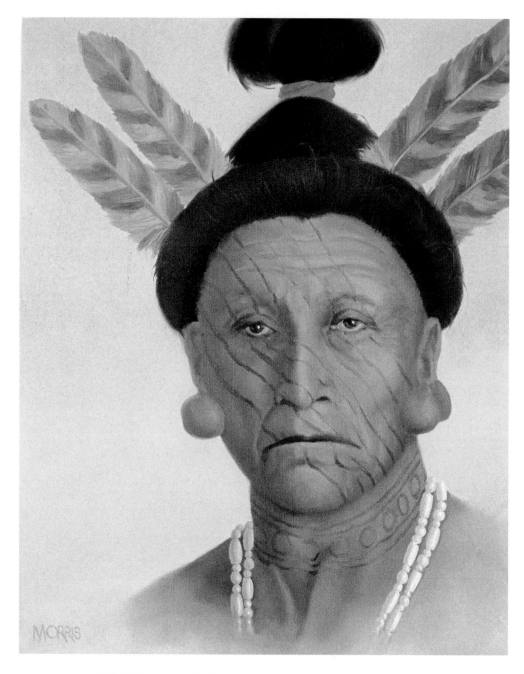

Chief (Timucua tribe)

This portrait of a Timucuan chief of northeast Florida is based on a Theodore de Bry engraving. Tattoos were made by incising the skin and rubbing dye into the tiny cuts. In this image, I wanted to give the subject an expression that reflects both his authority and weighty responsibilities. (Artifacts and objects: hawk feathers; painted fish-bladder ear decorations; shell bead necklace; face and neck tattoos. St. Marys culture. Private collection.)

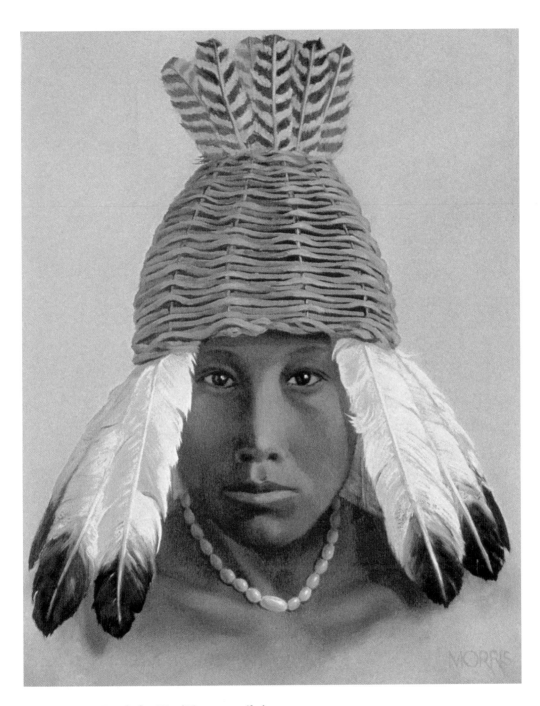

Ready for War (Timucua tribe)

The Timucua periodically went to war with other tribes. Here, a young warrior contemplates his first battle and his initiation into adult life. In this painting, based on a Theodore de Bry engraving, I maintain a neutral background in order to focus viewer attention on the boy's face and the trepidation reflected in his eyes. (Artifacts and objects: hawk feathers; helmet made from sabal palm roots; shell bead necklace; eagle feathers. St. Marys culture. Private collection.)

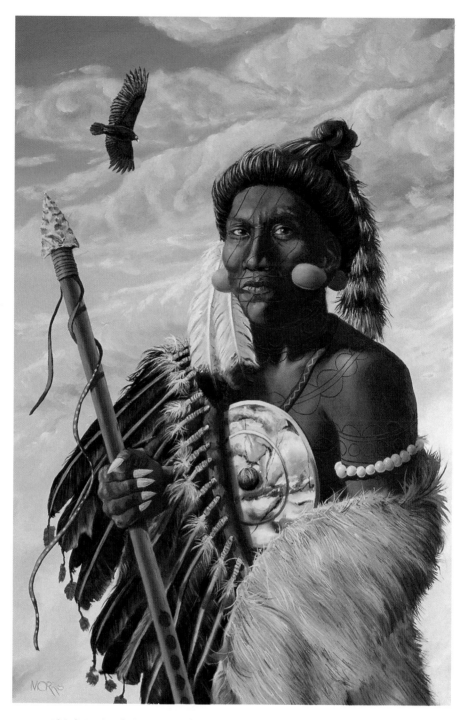

Chief Outina (Timucua tribe)

This red-painted Timucuan chief lived west of the St. Johns River in Putnam or Clay County. Here, according to a 1564 French account, he walked in solitary grandeur among his warriors. Outina's confrontational glare almost seems to challenge the viewer. (Artifacts and objects: turkey vulture; raccoon tail; eagle feathers; tattoos; painted fish-bladder ear decorations; turkey vulture feathers; copper breast plate; shell beads; deer hide robe; chert spear point; painted hide straps. St. Johns culture.)

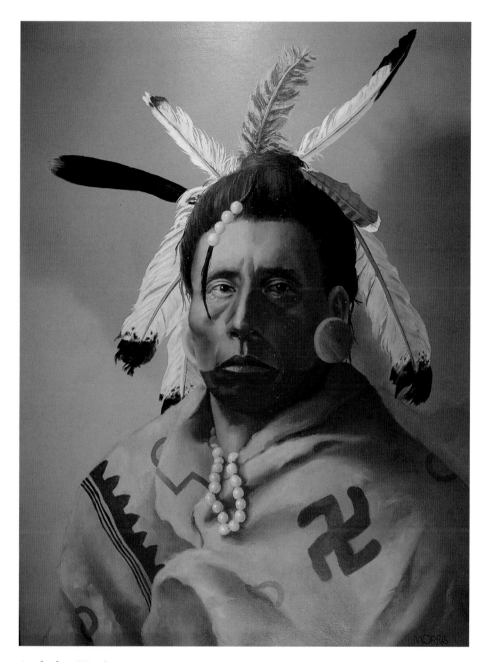

Apalachee Warrior

One of the more remarkable descriptions of Apalachee battle adornment comes from a seventeenth-century Franciscan missionary friar: "In order to give battle they dress themselves elaborately, after their usage, painted all over with red ochre and with their heads full of multicolored feathers." In this painting, I try to capture the warrior's intensity. The symbols on his deerskin robe are taken from actual designs on pottery recovered at archaeological sites. (Artifacts and objects: seagull, turkey, cormorant, eagle, and blue jay feathers; shell hair beads; copper ear decorations; pearl necklace; painted deerskin robe. Fort Walton culture.)

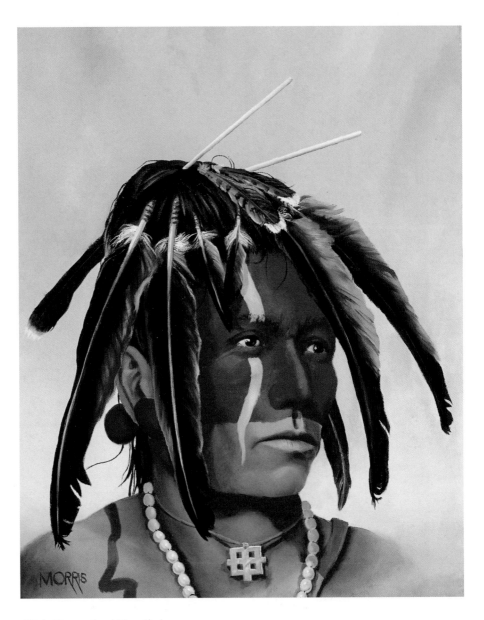

High Counselor (Ais tribe)

This Ais tribesman was one of a small group of principal men who counseled with the cacique in decision-making. His body painted and hair dressed, he is adorned to attend a reception for visiting dignitaries. Here, they will exchange gifts and drink cassina. In this portrait, I wanted to show discretion and intelligence in the tribesman's countenance. (Artifacts and objects: bone hairpins; blue jay, cormorant, and turkey vulture feathers; face and body paint; fish-bladder ear decorations; carved shell beads; silver pendant; deerskin strap. Perhaps Indian River culture.)

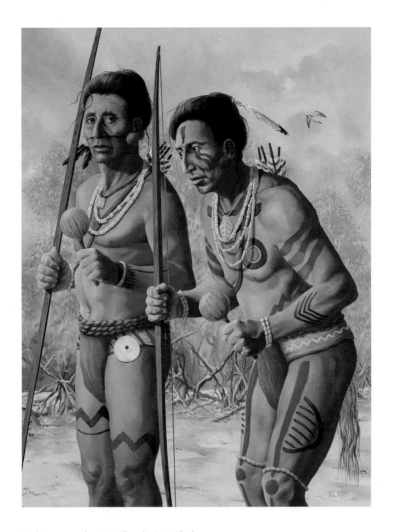

Taking up the Rattles (Ais tribe)

This work illustrates an episode witnessed in 1696 by the shipwrecked Philadelphian, Jonathan Dickinson. Six male Ais tribesmen began a ceremony of dancing and singing after placing a red and white pole in the ground. Dickinson wrote in his journal, "This being done, the most of them having painted themselves, some red, some black, some with black and red; with their belly girt up as tight as well they can girt themselves and their bows in their hands, being gathered together about this staff; six of the chiefest men in esteem amongst them, especially one who is their doctor, and much esteemed, taking up the rattles begins a hideous noise, standing round this staff, taking their rattles and bowing, without ceasing unto the staff for about half an hour." To show more detail, I painted only two of the six men described in the account. One looks directly out at the viewer, drawing us into the canvas and, by implication, into the tribal ceremony. (Artifacts and objects: left figure—bow; carved bone hairpin; fish-bladder ear decorations; pelican feathers; body paint; hawk-feather arrows; silver pendant; shell beads and shell bead bracelets; leather quiver strap; gourd rattle; rope; colored straw belt and front covering; copper-over-wood disc; right figure—bow; seagull feather and carved bone hairpin; body paint; hawk-feather arrows; silver pendant; shell beads and copper beads; shell bead bracelets; gourd rattle; rope; colored straw belt and front covering; carved shell beads at knees; grass "horse tail"; black skimmer bird. Perhaps Indian River Culture.)

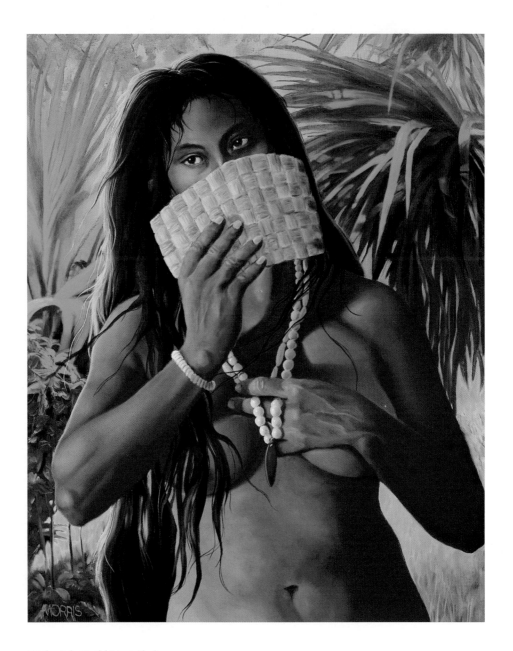

Girl with Veil (Ais tribe)

In the journal of his shipwreck adventure on the east coat of Florida, Jonathan Dickinson described the third day activities of a men's dancing ceremony: "many Indians [came] from other towns. This day they [Ais tribesmen] were stricter than the other two days, for no man must look upon them; but if any of their women go out of their houses, they go veiled with a mat." (Artifacts and objects: veil of woven palmetto fronds; carved shell necklace; pearl necklace with quartz crystal pendant. Perhaps Indian River culture. Private collection.)

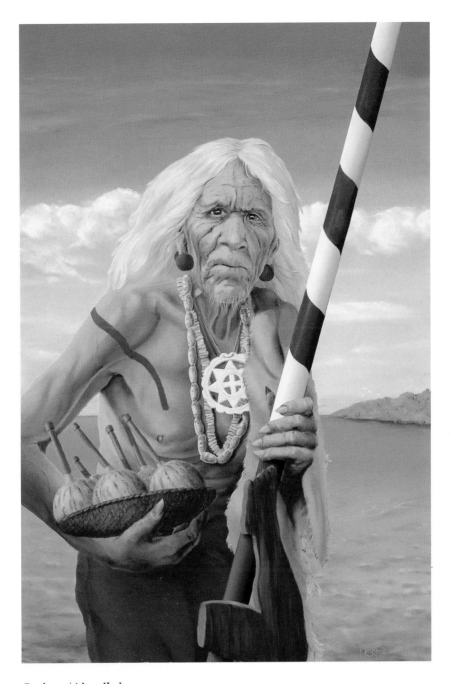

Cacique (Ais tribe)

This cacique is preparing for the ceremonial dance described by Jonathan Dickinson in 1696. The painted pole with the carved wood leg will be driven into the earth, and six men—painted red and black and holding rattles, bows, and arrows—will dance around it. The cacique's fierce, determined visage reflects his status as a leader. (Artifacts and objects: fish-bladder ear decorations; Oliva shell necklace; carved shell bead necklace; shell gorget; buckskin; wood pole; gourd rattles with wood handles; dyed red cloth. Perhaps Indian River culture. Collection of Indian River County Main Library.)

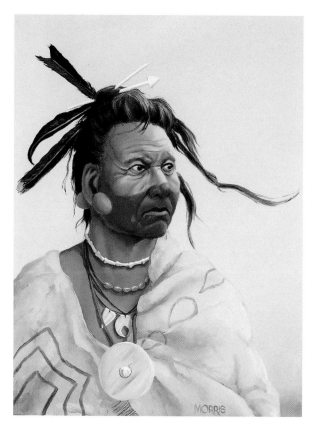

The Painted Caseekey (Jeaga tribe)

Jonathan Dickinson, who encountered the Jeaga in 1696, described firsthand the "caseekey [cacique] . . . dressing his head and painting himself." For his reentry into his village, the cacique—one of whose charges was food distribution—was "newly painted red." The copper disc conceals the large breasts that the Jeaga considered a deformity. The cacique's many personal adornments and polychromatic face paint reflect the complexity of his culture. (Artifacts and objects: cormorant and eagle feathers; bone hairpins; fish-bladder ear decorations; painted deerskin; human finger bone necklace; glass beads; silver pendants; copper-covered wood disc. Variant of Glades culture.)

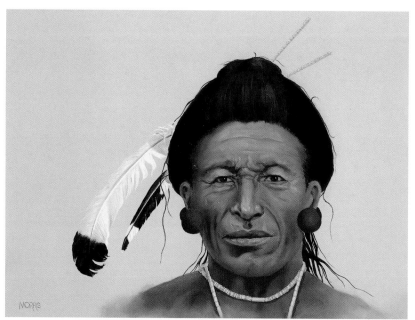

Elder (Ais tribe)

The Ais tribesman in this painting looks thoughtful and concerned. I try to show in his face the life-born wisdom that distinguishes him as a tribal elder. (Artifacts and objects: carved bone hairpins; seagull and eagle feathers; fish-bladder ear decorations; carved shell beads. Perhaps Indian River culture.)

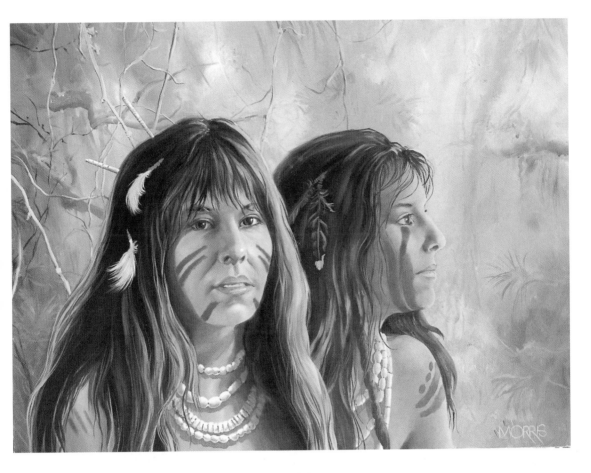

Moon Dance Women (Jeaga tribe)

Two Jeaga women prepare to join in an evening ceremonial dance. One will sing, while the other dances until midnight. I try to capture with color the atmosphere as dusk descends. I also hope to show in the women's faces their youthful anticipation of an event that must have been a welcome respite from daily chores. (Artifacts and objects: bone hairpins; egret and blue jay feathers; face paint; carved shell beads. Variant of Glades culture.)

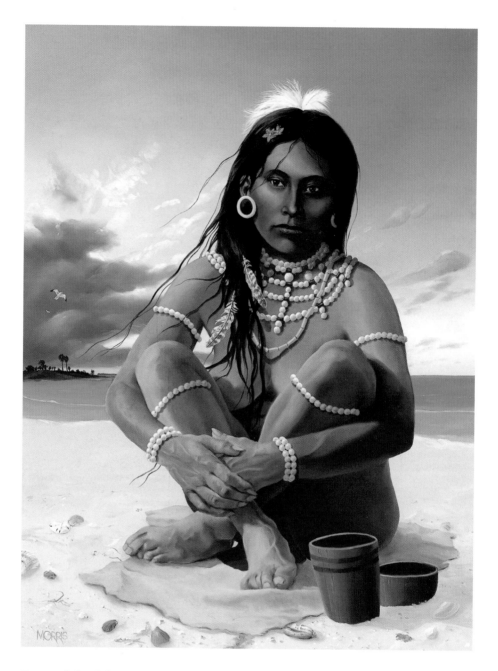

Queen of the Calusa

Although we do not know her formal name, the principal wife of the cacique, Carlos, was, at twenty, very beautiful. According to a sixteenth-century Spanish account, she had fine hands and eyes, shapely, well-marked eyebrows, and wore at her throat a gold bead necklace and a beautiful collar of pearls and stones. By placing her alone on the shore, surrounded by quiet beauty, I emphasize the singularity of her identity and position. Her queenly status would probably have afforded her few moments of privacy like this one. (Artifacts and objects: egret plumes; sky flowers; shell-and-wood ear decorations; pearl and stone necklace; gold rolled-bead necklace; pearl bead arm and leg bracelets; turkey feathers; deerskin; carved wood bowls. Caloosahatchee culture. Collection of Justyna Clipper.)

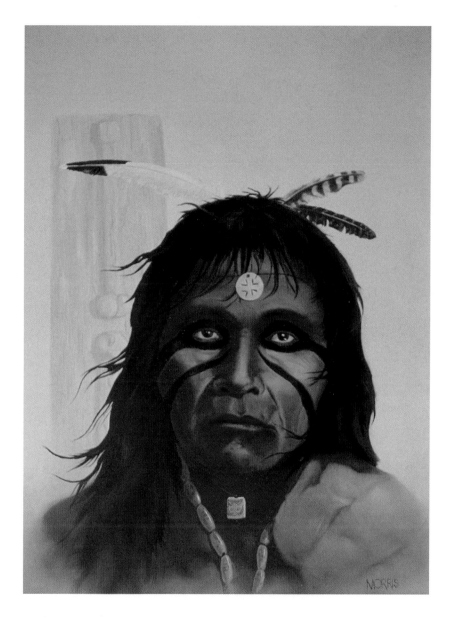

Carlos, King of the Calusa

Carlos was the name the Spaniards gave the sixteenth-century Calusa leader whose position, they felt, resembled a king's. Not only cacique of the Calusa, Carlos dominated all other tribes over a large portion of south Florida. As befits his position as paramount chief, I depicted a grave expression to suggest his deeply serious nature. (Artifacts and objects: ceremonial carved wood plaque; hawk and seagull feathers; silver disc on forehead; face paint; Oliva shell bead necklace; carved bone pendant. Caloosahatchee culture. Collection of Collier County Museum.)

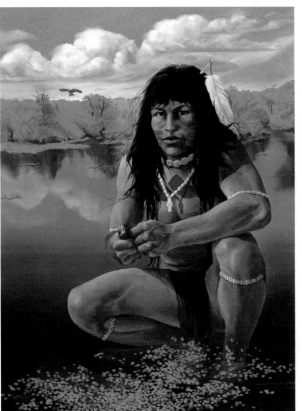

Tequesta with Apple Snail

Poised at the edge of the Everglades, a tribal hunter examines the apple snail he has gathered as food for a family celebration. Since the Tequesta did not plant crops, they relied heavily on the large variety of foods supplied by their rich, watery environment. The eagle feather hanging from the hunter's hairpin could be a symbol of some brave accomplishment. The bird in the background is a snail kite, which lives exclusively on apple snails. In this painting, I suggest the crucial role even a simple creature like an apple snail played in the natural world of the Tequesta Indians. (Artifacts and objects: carved bone hairpin and eagle feather; stone bead necklace; shell beads with carved bone pendant; deerskin breechcloth; stone bead leg bands; shell bead armband. Glades culture.)

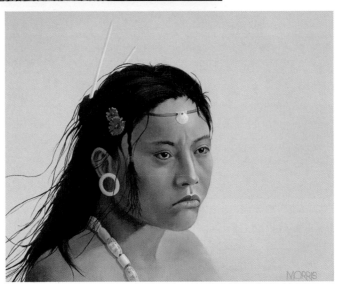

Bride of Conflict (Calusa tribe)

It was a Calusa custom that the chief marry a relative of a conquered chief to maintain order and loyalty among the new people of his chiefdom. This young tribeswoman faces a dilemma, and her face expresses perplexity over her new role: she must maintain loyalty to her own tribe, while at the same time fulfilling her new position as wife of the conqueror. (Artifacts and objects: carved bone hairpins; Gaillardia flowers; bay scallop on leather headband; carved shell ear decoration with wood inlay; Oliva shells with carved shell beads. Caloosahatchee culture.)

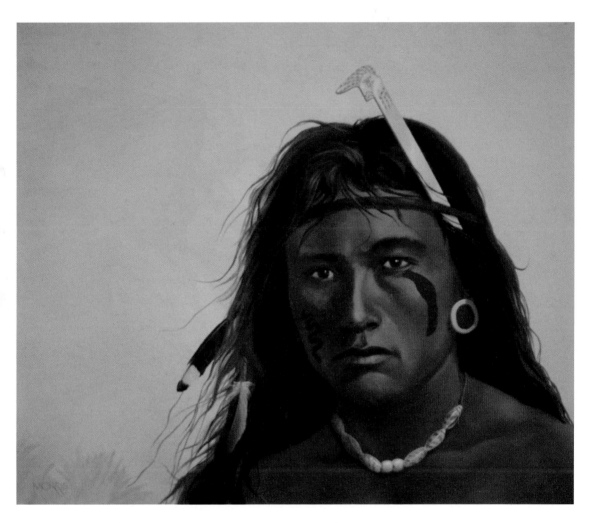

Spirit of Strength (Calusa tribe)

This young warrior projects a demeanor of inner strength and determination that was common among his people. The Calusa resisted the influence of the Spanish missionaries to a greater degree than any other tribe in Florida. Until their numbers were diminished and they were significantly weakened, they held on to their ancient spiritual beliefs. Here, I portray one of the younger warriors ready to assume his adult role. He is handsome, brave, and ready to prove himself. Woodpecker hairpins similar to the one he wears—all made from salvage metal from wrecked Spanish ships—have been found in south Florida archaeological sites. (Artifacts and objects: woodpecker design silver hairpin; deer hide headband; face paint; shell with wood inlay ear decoration; Oliva shell bead and carved shell necklace; pelican and seagull feathers. Caloosahatchee culture. Private collection.)

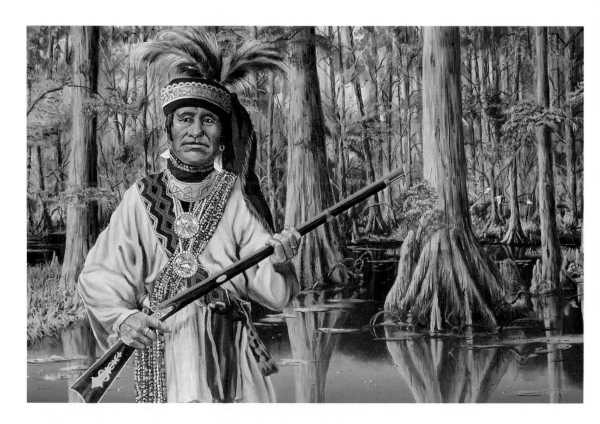

Holata Micco, or Billy Bowlegs (Seminole Tribe)

After the end of the Second Seminole War, Holata Micco and his followers lived in peace with the white settlers near their home in the Big Cypress Swamp. In 1855, Holata Micco and thirty of his warriors attacked an Army survey party who were secretly pinpointing Seminole villages, fields, and livestock for future attacks. This started the Third Seminole War. In 1858, Holata Micco surrendered, along with 123 of his followers, and was exiled permanently to Oklahoma. I based the clothing and accouterments depicted here on similar examples shown in nineteenth-century images and housed in museum collections.

culture (ca. 500 B.C. to about A.D. 100) and was most prevalent on the opposite side of the state along the Gulf coast of the Panhandle down to Cedar Key or so. There is evidence that some Deptford people began to move away from the coast to inland locations of the Panhandle and northern peninsular Florida after about A.D. 1, perhaps the result of expanding populations or for some other reasons.

Coastal Deptford villages were most commonly small and located adjacent to salt marshes, tidal streams, and coastal forests. The Gulf and inshore saltwater wetlands provided a host of fish and shellfish species for food. Other plants and animals came from the forests and the freshwater sources within them. Small camps, perhaps occupied intermittently for hunting or for some other purpose, are found away from the coast. The post-A.D. 1 inland villages generally are found in locales with both freshwater wetland and forest habitats, both of which could provide food.

Compared to St. Johns sites, coastal Deptford sites are smaller, suggesting that few people lived in these villages. Perhaps only a double handful of houses were occupied at any one time. The interior Deptford villages are larger than the coastal ones, suggesting growing populations and new economic emphases. Archaeologists suspect that Deptford societies were organized like the earliest St. Johns societies; there is no evidence for the political complexity which appeared in later St. Johns times.

Santa Rosa–Swift Creek and Swift Creek Cultures

The Panhandle Gulf coast did not remain a backwater for long. The rivers of northwest Florida served as communication routes between the coastal dwellers and the many native cultures to the north in Alabama and Georgia. New ideas, and perhaps new people, entered the Panhandle. Beginning about A.D. 100 or shortly after, the Deptford culture was replaced by the Santa Rosa–Swift Creek culture (in the western Panhandle) and the Swift Creek culture (in the eastern Panhandle).

That new ideas and even populations moved in (and out of) Florida during pre-Columbian times is not at all surprising. Like all humans, the Florida Indians were quick to take advantage of novel new ideas—things like the bow and arrow. And along with ideas and inventions, people also moved. Migrations might occur when populations grew too large for local resources and new hunting grounds were sought;

when conflicts with other groups caused disruptions; and when more fertile soils for agriculture were needed. People, often just a few families in the vanguard followed by larger numbers, were "pushed" by the conditions at home and "pulled" by better conditions in their new locale.

The Santa Rosa–Swift Creek culture in the western Florida Panhandle, west of the Apalachicola River, had very close ties to contemporary cultures in the lower Mississippi River Valley east into southern Mississippi and Alabama. On the other hand, the Swift Creek culture east of the Apalachicola River shared many similarities with the Swift Creek people living farther north in the Chattahoochee River drainage and in southwest Georgia. It appears that some of these Georgia people moved into Florida, pushing into locations on the coast where Deptford people had lived and into localities of the state's interior, such as in the Tallahassee area. Most likely these new people merged with older Deptford populations.

Many of the Swift Creek middens, both those along the coastal estuaries and at inland locales, are shaped like large horseshoes, suggesting that houses were arranged in an annular pattern around a central plaza. Like the early St. Johns people, Swift Creek villagers practiced gardening, as well as fishing, hunting, and collecting shellfish and other animals and plants. Though details might have differed, we believe the general patterns of Swift Creek social, political, and religious life also were like those of the early St. Johns regions people.

Mounds for the deposition of human remains were built by Swift Creek villagers and many contain a rich array of ceramic, shell, stone, and even copper items, some traded into the state from the north. These objects were important to the Swift Creek villagers as items of religious and social significance.

Weeden Island Cultures

After about A.D. 250, the Swift Creek and Santa Rosa–Swift Creek cultures were replaced by the Weeden Island culture in the Panhandle. The transition from Swift Creek into Weeden Island seems to have been a long-term one, suggestive more of a gradual evolution than an abrupt population movement. Weeden Island sites are found both on the coast proper and in many inland locations. Weeden Island sites also appeared in interior northern Florida in Madison, Suwanee, and Columbia counties, and variants of the culture spread south into

Alachua County. Weeden Island sites replaced those of late Deptford populations on the peninsular Gulf coast and extended down into Sarasota County. Weeden Island sites also follow Swift Creek occupations in southeastern Alabama and southwestern Georgia. This wide geographical distribution may have been both the result of population movements and the introduction to and adoption of new ideas by existing populations.

Weeden Island villages with plazas, burial mounds, and sometimes other mounds used as bases for buildings or for other purposes are found in a variety of inland and coastal settings. Village middens often are horseshoe-shaped, like those of the earlier Swift Creek people. Mounds were used in conjunction with charnel houses, and both bundles of cleaned bones and, occasionally, entire bodies were stored in the charnel houses before burial in mounds.

As in the later St. Johns culture, some Weeden Island villages and their leaders gained prestige and power. For a time, perhaps as little as one generation, those villages, like the McKeithen site in Columbia County, became centers of Weeden Island life and culture. At McKeithen, for instance, three mounds, all built around A.D. 350, and a horseshoe-shaped village surrounded a central plaza on the south side of a creek. The village was much grander than any others in the region. Though the village's status could not be maintained, people continued to live at the site for several hundred years, perhaps basking in the glory that once had been.

Prior to A.D. 750, the McKeithen villagers and other early Weeden Island peoples relied most heavily on wild food for their sustenance, though they may have done some gardening as well. In various regions, different Weeden Island populations emphasized different constellations of resources. As we might suspect, those living on the Gulf coast relied heavily on fish and shellfish from the shallow inshore Gulf waters, salt marshes, and estuaries, while inland villagers fished freshwater lakes, hunted, and collected wild foods in the hardwood forests. Though such economic differences existed, archaeologists still feel that Weeden Island people shared many of the same beliefs and social and political institutions. The exact same animal-shaped, fired-clay pottery vessels are found throughout the Weeden Island region. Some of those vessels, as well as copies of them, are found at St. Johns sites in northeast Florida, while St. Johns vessels are found at Weeden Island sites. None of the Florida Indians lived in isolation.

Archaeologists recognize a number of changes in the Weeden Island culture after A.D. 750. Some surmise these changes are due to the

adoption of corn agriculture, though, as with reference to the St. Johns region, this is still a matter of debate. Still, the changes that we can observe—changes in village layout; the seeming scattering of many families across the landscape in smaller groupings, perhaps related to a search for agricultural soils; a decline in communal mound building; and the disappearance of animal effigy vessels thought to be associated with shared beliefs—all point toward changes in subsistence practices.

Fort Walton and Other Farming Cultures

Certainly corn was being grown by the late Weeden Island people in the eastern Panhandle by A.D. 850; kernels found at a small homestead just east of the Apalachicola River have been radiocarbon-dated to the ninth century. Shortly after that time, by A.D. 1,000, the late Weeden Island culture in the Panhandle had evolved into a new culture, one archaeologists call Fort Walton. Fort Walton sites—both villages and farming homesteads—quickly filled the interior of the Panhandle, especially in the Tallahassee Red Hills of Leon and Jefferson counties. Fort Walton sites also are found along the coast. Farming, especially growing corn, squashes, and beans, provided the economic base for the Fort Walton culture people. Indeed, the Fort Walton people were pre-Columbian Florida's premier farmers. Their success is reflected in archaeological evidence: more pre-Columbian corn has been found at Fort Walton sites than in all the other Florida sites combined.

Like the late St. Johns cultures, Fort Walton societies were organized as chiefdoms. But with greater agricultural yield—thanks to the region's fertile soils and to farming methods geared to intensive production—Fort Walton populations were denser in number and their societies were more hierarchical than those in northeast Florida. Each Fort Walton chiefdom was arranged like a triangle. At the base of the social and settlement system were the bulk of the people, farming families who lived at literally hundreds of agricultural homesteads scattered across the landscape. Just above them were small villages where homesteaders went for communal activities and where local village officials lived. Still further up the social ladder were regional village centers where more important chiefly officials lived—regional chiefs, for example, each of whom had lower-ranked village chiefs as vassals. These regional village centers probably featured ramped mounds, built at the behest of chiefs as the bases for chiefly resi-

dences, temples, and buildings of other purposes. Ramps or stairways gave access to building summits from which chiefs could look out across village plazas where commoners assembled for religious and other communal festivities. Farmers might have paid agricultural produce and other goods as tribute to their local chiefs, who in turn passed a portion on to regional chiefs.

At the top of the social and political triangle were the paramount chief and his family who lived at the main chiefdom town, a town where laborers erected multiple mounds around plazas to serve as bases for buildings. The chief and members of his family, attired in symbols of their high office and accompanied by paraphernalia reflecting their elevated status in life, were buried in the floors of the temples.

The most important pre-Columbian Fort Walton chiefdom was in Leon and Jefferson counties between the Aucilla and Ocklockonee rivers. At least several generations of chiefs who ruled the region lived at their capital town, identified by archaeologists as the Lake Jackson site not far from Tallahassee, Florida. That site today has seven rectangular mounds, six of which are arranged in pairs in two rows separated by a small stream. The largest mound has a base of nearly ninety by one hundred yards and is thirty-six feet high with a ramp built up its east side.

One of the mounds, ramped and pyramidal in shape with a flat top, was excavated by Florida Bureau of Archaeological Research archaeologist, B. Calvin Jones. Jones identified twelve building floors in the mound, each the floor of a temple built on top of the mound. Over time—radiocarbon dates indicate a period of 235 years—each temple was razed, then covered with a new mound layer, and a new temple built. Each of the twelve rebuilding stages increased the size and height of the mound.

As they were in life, members of the Lake Jackson ruling family were wrapped in luxury, symbols of their wealth and importance, when they were buried. Tombs contained pieces of woven cane matting, cloth made from plant fibers, and leather clothing. Also interred were magnificent objects made of copper, lead, mica, anthracite, graphite, steatite, and green stone—all goods obtained from well beyond Florida's borders. There were axes and ax bits made of imported stone; beads made from pearls; and a profusion of shell objects, including small beads, huge (nearly 1 3/4 inch-long) beads made from the columellae of *Busycon*, cups, and decorative gorgets and pendants. Other items recovered by Jones during his excavations included ceramic ves-

sels; bone hairpins inlaid with copper; a belt clasp of galena; smoking pipes of steatite and of clay (one in the shape of a lizard); a mirror made of mica backed by galena; and a palette with red and yellow minerals on it which had been used as paint.

Perhaps most prominent were the items fashioned of copper, a metal highly valued by southeastern Indians and one which tended to be associated with chiefs and their families. Nine decorated copper breastplates in the shape of birds were uncovered, along with pieces of copper plates wrapped in cloth. Perhaps even when broken and worn out, copper was still so imbued with importance that it was afforded special treatment. Found also with the high status burials in the Lake Jackson mound were ax bits, arrow-shaped headdress ornaments, other hair ornaments, small oval plates, and pendants, all made of copper.

Religious and other symbols were prominent among all southeastern Indians, and those found at Lake Jackson bear many resemblances to those associated with chiefs and leaders among other agricultural cultures. Found across the Southeast among farming populations, some symbols and objects are associated with various mythical beings who inhabited worlds beyond earth. Some of these beings appear to be figured as eagles, hawks, and falcons. Copper plates, like several from the Lake Jackson site, sometimes depict chiefs and priest-chiefs wearing costumes which turned them into these otherworldly beings. Other symbolic entities, such as rattlesnake beings, may be tied to agricultural fertility, while still others are related to warfare. Another group of symbols is associated with chiefly powers, the hierarchy of chiefs and priest-chiefs, and the adoration of chiefly lineages. The belief systems of the Fort Walton people and other southeastern Indians were as complex as those associated with any religions in the world.

The Fort Walton farmers, who served the chiefs and their families along with other officials and religious leaders living at Lake Jackson, also held a set of common beliefs and shared symbols. The antecedents of many of those symbols probably lie deep in the past; some may have been derived from earlier Weeden Island beliefs. Many of the symbols—volutes, scrolls, loops and circles—are incised on ceramic vessels. They may have been mnemonic devices for beliefs about the world and cosmos. Some pottery vessels are stylized animals or are adorned with modeled clay heads representing a host of animals: eagles, woodpeckers, ducks, geese, quail, herons, owls, turkeys, vultures, snakes, lizards, alligators, frogs, foxes, otters, opossums, squirrels, dogs, bears, and panthers—all animals important to Fort Walton

beliefs. Such beliefs helped the Fort Walton farmers to understand their world and their place in it.

When Europeans arrived in Florida, they encountered the Apalachee Indians living in the Tallahassee region. The Apalachee were the sixteenth-century manifestation of the Fort Walton chiefdom whose leaders for a time lived at the Lake Jackson site. In 1539 when Hernando de Soto and his army marched into the then Apalachee Indian capital town of Anaica, they observed firsthand cultural practices handed down from the Indians' Fort Walton ancestors.

The Fort Walton and late St. Johns people were not the only regional cultures in pre-Columbian Florida who were farmers. After about A.D. 1,200, farming also was present among the Suwannee Valley culture in north Florida east of the Aucilla and north of the Santa Fe rivers. When the Hernando de Soto expedition marched though Columbia, Suwannee, and Madison counties in the summer of 1539, many small Timucua Indian agricultural chiefdoms associated with the Suwannee Valley culture lived in the region.

Immediately to the south in what are now Alachua and Marion counties were other agricultural Timucuan chiefdoms, such as that of the Potano Indians in the Gainesville locality. Those chiefdoms, some of which also witnessed the passage of the de Soto expedition in 1539, were associated with the Alachua culture, a regional culture which appeared in north-central Florida about A.D. 600. The de Soto chroniclers commented on the corn fields in the region.

Safety Harbor Culture

After A.D. 900, another regional culture, Safety Harbor, developed out of late Weeden Island populations in the geographical area from Sarasota County northward around Tampa Bay to the Withlacoochee River drainage where Citrus, Marion, and Sumter counties meet. Safety Harbor people living on Tampa Bay did not grow corn; like their Weeden Island ancestors they made their living by fishing, hunting, and collecting shellfish and other foods. It is likely they maintained gardens, though archaeological evidence has not yet been found. Farther north, from about Dade City to the Withlacoochee River, Safety Harbor people did grow corn.

When the Pánfilo de Nárvaez (1528) and Hernando de Soto (1539) expeditions explored Tampa Bay, they met a number of Safety Harbor groups, including the Uzita, Mocoso, Pohoy, and Tocobaga Indians, all

small chiefdoms of the Safety Harbor culture. The villages of these groups dotted the shoreline of Tampa Bay. The main village of each chiefdom included temple mounds associated with the chiefs and their families; charnel houses and burial mounds; central plazas; and village areas where most of the people lived. Villages and mounds also were present inland, away from the coast, especially where wetlands helped to provide food.

Belle Glade, Glades, and Caloosahatchee Cultures

Regional cultures also were well established in south Florida by 500 B.C. or a few hundred years earlier. Archaeologists recognize three main cultures in that area, as well as several smaller (in distribution) related cultures. All depended heavily on either the vast inland wetlands or coastal areas that still typify most of the region today.

One regional culture, Belle Glade, was centered around Lake Okeechobee—called Lake Mayaimi by south Florida Indians—and its adjacent wetlands and savannas, including north up the Kissimmee River drainage to Polk County. (A related culture east of Lake Okeechobee in Palm Beach County was a variant of Belle Glade.)

The wetlands and savannas of the Lake Okeechobee Basin provided the Belle Glade villagers with a plethora of fish, turtles, alligators, and other animal and plant foods. Though they ate nearly everything that swam or crawled in or beside the many wetlands in that region, evidence for the eating of wading, water birds, such as wood ibises, herons, and the like, is strangely lacking. Perhaps there were taboos against eating these animals.

The Belle Glade people lived in numerous small settlements scattered across the basin savannas and around the shore of Lake Okeechobee, then much larger than it is now. They also maintained village centers at which they built burial mounds and an assortment of remarkable earthen embankments and other earthworks, some in geometric shapes. Archaeologists are still debating the significance of these extraordinary constructions.

Along with the earthworks, archaeologists have found large, circular ditches and ponds, which the Belle Glade people may have used for agricultural and domestic drainage purposes or perhaps in ceremonial activities. They also dug artificial charnel ponds in which they erected wooden platforms where the cleaned, bundled bones of deceased relatives were stored. The platform excavated by William H. Sears at the

Fort Center site west of Lake Okeechobee had been adorned with life-size and larger-than-life wooden carvings depicting a host of animals, including wading birds, the same birds whose bones are absent from Belle Glade middens. Belle Glade people also dug canals, some several miles long, which were used for canoe passage.

By 500 B.C., the second major south Florida regional culture, the Glades culture, inhabited the large area south and southeast of the Belle Glade culture, including the mangrove coasts and estuaries of southeast Florida, the Ten Thousand Islands, and the coast from Cape Sable through the Florida Keys. Glades sites also are found throughout the Everglades, Big Cypress Swamp, and other portions of southern-most interior south Florida. Within this large area there were varia-tions of the Glades culture, such as east of Lake Okeechobee.

Like the other south Florida people, the Glades people fished, gath-ered shellfish, and collected plants and other animals. In Dade County, the sixteenth-century descendants of the Glades populations were the Tequesta Indians. North along the Atlantic coast south of Brevard County resided many different small Indians groups, includ-ing the Jobe, Jeaga, Bocaratones, and Santaluces, the latter two exhib-iting names given the Indians by the Spaniards. Many other Indian societies flourished in the Glades region, but we know little about them today, because they lived outside those areas visited by Span-iards or other Europeans.

In the sixteenth century the southwest Florida coast from Char-lotte Harbor down to Marco Island was the domain of the Calusa Indi-ans, a large chiefdom affiliated with the Caloosahatchee culture, the third major south Florida regional culture and one also dating back at least to 500 B.C. The coastal realm of these marine-oriented Indians, especially the islands and adjacent mainland of Charlotte Harbor, Pine Island Sound, and San Carlos Bay, features numerous large and small shell middens containing millions of fish bones—the remains of thou-sands of meals eaten by the Caloosahatchee people.

By A.D. 800, Caloosahatchee society was organized into chiefdoms. Major towns were built, most adjacent to the water. There is archaeo-logical evidence suggesting houses actually were built on stilts above the water. Some towns also featured shell and earthen mounds and other shell works. Temples and chiefly dwellings were built atop some of the mounds, as they were in northeast and northwest Florida. But though the Caloosahatchee kept gardens, they were not farmers. They did not need corn or other agricultural products to support large populations and a social hierarchy. Instead, their political complexity

was based on harvesting the shallow inshore waters of the bays and sounds. Marine foods provided as substantial an economic base as did corn among the north Florida cultures.

The Caloosahatchee people built canals, some several miles long like the one across Pine Island in Lee County. These were used as canoe byways, shortening travel distances and providing shelter from rough inshore waters. The Pine Island canal led several miles from Pine Island Sound to the east side of the island. Other canals were constructed so that canoeists could paddle from the open water into the interior of villages, where canoe basins, like the gondola basins of Venice, Italy, served as landings. The world of these ancestors of the Calusa Indians was truly a water world.

THE LOST TRIBES

In 1513 the Spaniard Ponce de Leon landed on Florida's Atlantic coast, the first documented European to see Florida and the estimated 350,000 Indians who lived there. The Indians were the descendants of people who had been in Florida for hundreds of years. Ancestry of some groups no doubt went back thousands of years. Some of the Indians were farmers, others maintained gardens, and all relied heavily on hunting, fishing, and collecting wild foods. Most if not all were politically organized as chiefdoms, some large and complex, others small and simple. Though they shared aspects of their cultures and maintained similar organizational structures, they spoke many different languages and maintained different lifeways.

Except for handfuls of people who fled the state, all of these Florida Indians had ceased to exist by the mid-eighteenth century, victims of disease introduced from Europe, warfare, slave raids, and dwindling birth rates. The ravages of colonialism were immense.

Everything we know about these people comes from archaeology and from documents left behind by the French and Spanish who sought to colonize Florida. It is an artist's meticulous translation of these sources into visual form that has helped bring individual Florida Indians out of the past and into the present. Though one might think we have sufficient information on hand to assign an archaeological culture to every colonial period native group, that is not always the case. For some groups, such as the Ais, there is uncertainty concerning their boundaries; for others, like the Ocale, we lack information on

the archaeological cultures affiliated with them. Even so, much more is known today than in the 1970s and before. We are making progress.

Timucua Indians

When the Spanish conquistadors Pánfilo de Nárvaez and Hernando de Soto entered northern Florida in the early sixteenth century they encountered chiefdoms whose people spoke dialects of the Timucua language. Later, French soldiers and settlers and, then, Spanish soldiers, settlers, and missionary friars would encounter still more chiefdoms as European monarchies sought to conquer the land Ponce de Leon had named La Florida. Even by the first decades of the seventeenth century, however, diseases brought from the Old World already had reduced the Indian population of the state.

Together, the forty or so Timucua chiefdoms that existed at the time of first European contact had a population of as many as 200,000 people. Their homes lay within a large region of north peninsular Florida extending from the Aucilla River east to the Atlantic Ocean and south into central Florida. Timucua Indians also lived in a significant portion of southern Georgia from the Altamaha River southward, including Georgia's lower Sea Islands. Among these Timucua chiefdoms were the Potano in modern Alachua County, the Ocale in western Marion or northeast Sumter counties, and the Saturiwa (also spelled Satouriwa) near the mouth of the St. Johns River. The histories of the individual chiefdoms are quite diverse. The Timucua developed out of a number of different regional cultures.

At times, a powerful chief would forge an alliance with other chiefs, forming a confederation of chiefdoms and a number of individual villages and village chiefs. In 1564, one such alliance, headed by Chief Saturiwa, was said to include at least thirty other chiefs living in what is now the Duval–St. Johns County coastal area. Chief Outina, who lived in the Lake Grandin locality in northwestern Putnam County, headed a second alliance of forty chiefs living in the St. Johns River drainage south of Jacksonville. Still other alliances were formed in interior north Florida and along the southeast Georgia and northeastern-most Florida coasts. As among the pre-Columbian St. Johns culture chiefdoms, the power of these paramount chiefs and the nature of their alliance changed as political fortunes waxed and waned in response to other factors. The presence of the Europeans beginning in the sixteenth century, as well as the disease-driven depopulation which occurred, were instrumental in further altering alliances.

Among the Timucua, the name for a chief was *holata*, though the Spaniards usually referred to chiefs as *caciques*, a word they had borrowed from the Indians of the Caribbean. Important chiefs—those most powerful, who probably headed alliances—were called *holata outina* (*utina*). Several chiefly officials served as aides. The *inija* spoke on the chief's behalf, while the *anacotima*, second anacotima, and *afetema* performed other duties, the exact nature of which is uncertain.

In times of war, a different chief and his aides assumed responsibility for military efforts. Among the Timucua, the war chief was known as *uriutina* or *irriparacusi* (the prefix *uri* or *irri* meant war). Other war officials may have been the leaders called *ibitano, toponole, bichara, amalachini,* and *itorimitono*. Other of the southeastern Indians maintained a similar dichotomy of civil and war chiefs.

Chiefs and chiefly officials came from specific clans, which were ranked in status relative to one another. Timucua clans had names such as Bear, Buzzard, Earth, Fish, Quail, and White Deer, and all were matrilineal; that is, a person was always a member of the same clan as his or her mother. Thus, if your mother were a Bear clan member, you and your brothers and sisters all would be members of the Bear clan.

Because members of the same clan could not marry, a child's father always came from a different clan. Chiefs tended to be males, though not always, and they generally belonged to the White Deer clan. That meant that if your father were the town chief, you could not inherit his position, because you were not a White Deer clan member. Instead, the position would go to your cousin, the chief's (your father's) sister's son. These interlocking kin connections, like those among St. Johns villages in pre-Columbian times, served to unite societies and prevent conflicts.

Chiefs assisted by chiefly and village officials attended to the affairs of their communities, meeting in the village council house. Council houses were round buildings constructed of wood and thatch. Some were large enough to hold more than a hundred people. Those people were seated according to their respective ranks on wooden benches. Like the Apalachee council house excavated at the San Luis mission site in Tallahassee, Florida, and the houses Timucua villagers built (both described below), Timucua council houses were made of large poles or tree trunks leaned against a framework of large posts and connecting rafters. The palm-thatched buildings also served as places to lodge guests and to meet visiting officials, including Europeans.

Houses of Timucua villagers, each occupied by an individual family, were described by one Spanish observer as looking like pyramids.

Some may have been built by anchoring the butts of flexible wall posts into the ground and then bending their tops together and securing them. This initial framework was interwoven with smaller branches and then covered with palm thatch. Similar to council houses, other houses were built by raising a circle of vertical posts atop which horizontal rafters were secured. Next, larger posts were leaned against these supports, a framework of smaller branches crafted, and palm thatch added. The result was a building that looked very much like a round pyramid.

Inside their houses, the Indians slept on low wooden benches covered with pelts, leaves, or grass for softness. In winter, fires kindled in hearths in the centers of houses were used both for heat and for cooking. Smoke rose up through an opening left where the leaning wall supports came together. Pits dug into the floor and lined with grass or hide were used to store some foods. Pottery vessels and wooden boxes were also used for storage. Outside their houses, the Indians built wooden cribs in which to store ears of corn until the kernels were removed and ground into meal using log mortars and wooden pestles.

Just as their pre-Columbian ancestors of the St. Johns, Alachua, Suwannee Valley, and St. Marys cultures had done, the sixteenth-century Timucua Indians fed themselves by hunting, fishing, gathering wild foods and by growing corn, beans, squash, and other plants. They also grew tobacco, which was used as a ritual herb.

Fish were speared from canoes, as well as taken by nets and in weirs. Bows and arrows were used to hunt animals, especially deer, and at times the hunters disguised themselves in deer costumes to be able to get near their quarry. Snares were used, as were fire drives. Fires were lit to drive game toward waiting hunters or into nets strung to ensnare the animals so hunters could dispatch them.

The Timucua, like the other Florida Indians, were experts at utilizing their environment to get what they needed to live, and they also knew how to make maximum use of plants and parts of the animals they hunted and snared. Native doctors (*isucu*) knew which herbs to effect cures, and native priests (*yaba* or *jara*), performed rituals to assure successful hunts, foraging trips, and harvests. The latter also foretold the future, found lost items, and used magic to cure or to curse people.

As did other of the Florida Indians, the Timucua decorated themselves with paint and tattoos and wore bone hairpins and shell and bone ornaments. Their clothing was made from animal hides and plant fibers, including cloth made from Spanish moss. European accounts mention the distinctive hairstyle of the adult men and the

Timucua practice of wearing ear ornaments, including some fashioned from fish bladders.

Beginning in the sixteenth century, the various Timucua chiefdoms underwent many changes. The Indians sought first to cope with the European presence and the related disease-born epidemics that ravaged indigenous populations. Second, the Timucua faced efforts by Spanish officials to Christianize and incorporate them into the La Florida colony whose capital was Spanish St. Augustine.

By the time Franciscan mission efforts among the Timucua began in earnest in 1595, European diseases already had impacted Timucua chiefdoms. The Nárvaez expedition traveled through several western Timucua chiefdoms in 1528. The de Soto entrada followed in 1539. De Soto's soldiers marched through the heart of the interior north Florida chiefdoms on three occasions, including some of the same ones as Nárvaez.

From about 1515 until 1564, first Spanish, then French expeditions sailed along the coast of northeast Florida and southeast Georgia, contacting Timucua chiefdoms, including those on the lowermost (northern) St. Johns River. Here, in 1564, the French established a settlement. Though Fort Caroline was taken in 1565 by the Spaniards, who reoccupied it only days after establishing an encampment at what would become St. Augustine, the French, during their brief time in Florida, explored the St. Johns River and sent explorers across interior north Florida. These excursions were followed in the late 1560s by similar Spanish explorations.

Thus by the time of Franciscan mission efforts in 1595, the Timucua had been in intermittent contact with Europeans for more than three generations. The result of that contact was devastating for some of the Timucua, especially those people on the northern St. Johns River and in the vicinity of St. Augustine. By 1595, most had ceased to exist.

Beginning in 1595, missions were established among the Timucua chiefdoms in northern interior Florida and southeast Georgia, with one well up (south) the St. Johns River just north of Lake George. Other missions in St. Augustine were intended to serve the Indians who were brought to that town to work for the Spaniards. By 1620, only twenty-five years after Franciscan friars went out among the Timucua in any numbers, all the existing Timucua chiefdoms had received missionaries.

Native curers and shamans, along with many native beliefs, soon gave way to Catholic priests and their beliefs. The Timucua became Christians, though they would continue to follow their traditional

chiefs and to hold to many of their aboriginal ways, even while adopting aspects of Spanish culture, including some Spanish foods and crops.

Unfortunately, what initially may have seemed a successful program to bring the Timucua to Christianity—while using them to produce foodstuffs for the Spaniards and to supply labor for St. Augustine—quickly began to fail as native populations plummeted. Epidemics hit the missions again and again, beginning with the 1595 missions. Half the mission Indians were said to have died in the epidemics of 1613–1617. Severe epidemics also took their toll in 1649–1651 and in 1654–1655. By 1656, there were only about 2,000–2,500 Timucua Indians still living at missions. The once-flourishing Timucua chiefdoms were no more. By the end of the seventeenth century their number had dropped to only several hundred people.

In 1702–1705, a series of raids by Carolinian militia and their Indian allies destroyed most of the Timucua missions and forced the surviving population to seek refuge in new villages around St. Augustine. There they gradually faded away, victims of colonialism. When Spain relinquished her Florida colony to Great Britain in 1763, there was only one Timucua Indian among the Christian Indians shipped from St. Augustine to Cuba with the withdrawing Spaniards.

Apalachee Indians

Like their neighbors the Timucua Indians, the Apalachee Indians are well known from both archaeological excavations and from documentary records, including narratives written by members of the Hernando de Soto expedition which camped in an Apalachee town (Anaica) during the late fall and winter of 1539–1540. Like the Timucua, the Apalachee Indians were introduced to Catholicism by Franciscan friars who established missions in Apalachee beginning in the early 1630s. By that time, the pre-Columbian Fort Walton archaeological culture of their ancestors had changed into that of the Apalachee Indians, and the large mound centers that once were homes to Apalachee chiefs and their families no longer were occupied. Even so, the Apalachee still retained many traditional social, religious, and economic practices, and, like their Fort Walton ancestors, the majority of the Apalachee people lived at small farmsteads scattered across the countryside.

Apalachee was a Muskhogean language, a family of languages that includes Creek, Choctaw, Seminole, and other American Indian lan-

guages of the Southeast and, today, of Oklahoma. Many of the Indians living in the interior Southeast in the late pre-Columbian period probably also spoke Muskhogean languages. Timucua, on the other hand, appears to be unrelated to other Southeast Indian languages, and its origin remains a subject of debate.

The Apalachee Indians of the colonial period were Florida's most successful farmers, thanks to fertile agricultural soils. This was especially true for the Tallahassee Red Hills region between the Aucilla River and the Ochlockonee River in the eastern Panhandle. It is no coincidence that this region (in modern-day Leon and Jefferson counties) had the densest Indian population and was home to the most powerful native society in terms of military prowess. When the Pánfilo de Nárvaez expedition marched though Apalachee in 1528, there probably were as many as 50,000 Apalachee people living there.

Though the Apalachee may have suffered from epidemics introduced early in the colonial period, a Spanish account says there still were 107 towns in Apalachee in the early seventeenth century. Such a large population, and one which was so successful when it came to raising crops, did not escape the eyes of the Spaniards. It is no wonder de Soto chose to winter there, and it is no coincidence that Spanish governmental officials in St. Augustine sought a presence among the Apalachee. As the Timucua people declined in numbers, the Spaniards were forced to place more and more reliance on the Apalachee to produce the corn which helped feed St. Augustine's townspeople.

Unlike the north Florida Timucua-speakers, who comprised a number of relatively small chiefdoms, the Apalachee were organized as a single chiefdom ruled by a paramount chief, who, as in the Fort Walton culture, commanded a number of regional village chiefs as vassals. Regional chiefs in turn ruled over local village chiefs and their people. There is evidence the Apalachee maintained both a civic–religious hierarchy of chiefs as well as war chiefs, with some towns being aligned with the "white" chiefs (civil–religious leaders) and others with "red" chiefs (war chiefs).

The Apalachee paramount white chief and his associates controlled the redistribution of many resources within their province. Lesser chiefs also paid him tribute. De Soto's expedition accounts mention corn and other crops, rabbit furs, bear hides, and feather cloaks being paid to the chiefs.

By the time the first Franciscan missions were established in Apalachee, nearly a century after de Soto wintered there, the war chiefs were greatly reduced in power. The days of widespread warfare between the Apalachee and other Indians were gone. On the other hand,

the Spanish military and the Franciscan friars openly supported village chiefs as well as the regional and paramount chiefs. By allying themselves with the upper echelon of Apalachee leaders, the Spanish could essentially control the Apalachee population, including the many farmers who grew the corn exported to St. Augustine.

Beginning in 1633, and working through the chiefs, the Spanish friars established about a dozen missions in only one or two years. Each of the missions also served a number of outlying towns and the farmers who lived around them. Though the Apalachee population suffered from severe epidemics, the number of Indians appears to have stabilized at around 8,000 by 1650. As the Timucua mission system fell apart due to severe depopulation, the Apalachee, with their productive farming techniques, took on the role of breadbasket for St. Augustine. Spanish ranches and even ranches owned by Apalachee chiefs dotted the province, and foodstuffs and other goods—corn, hides, tallow, wheat—were loaded onto boats at a St. Marks River landing and shipped to St. Augustine. Sometimes, goods were carried to the Spanish capitol on the backs of Indian bearers.

As part of the effort to colonize the Apalachee and keep order, a small garrison of Spanish soldiers was stationed there. Over time, Spanish families also moved into the province. In the second half of the seventeenth century, the largest group of Spaniards in Florida outside St. Augustine was at the mission town of San Luis, located in modern-day Tallahassee.

Archaeologists from the Florida Bureau of Archaeological Research have carried out important excavations of the San Luis mission for a number of years. In addition to the mission church, the convent where the friars lived, and other Spanish buildings, the archaeologists uncovered the Apalachee council house and the house of the town's chief. The circular council house was built like the pyramid-shaped houses of the Timucua, only it was much, much larger, measuring 120 feet across. The large size required two concentric sets of interior vertical support posts, each arranged in a circle with horizontal supports across their tops to hold up the huge tree trunks that leaned against them. A latticework of wood was then attached to these leaning posts and a covering of palm thatch was placed atop. The leaning posts did not extend to the center of the roof, leaving an opening forty-six feet wide above the center of the house. Directly under the opening in the center of the council house floor was a large hearth surrounded by a dance floor sixty-five feet in diameter. Within the council house, people sat on one of two concentric circles of benches, each built around one of the circles of interior, vertical support posts. By any standards it was an

imposing structure, as was the smaller chief's house, which was similarly constructed, though with only one circle of interior support posts.

Among the Apalachee, as well as the Timucua, council houses continued in use throughout the seventeenth century, reflecting the perseverance of native chiefs and native political systems. On the other hand, as noted above, many native beliefs and the leaders associated with them disappeared. Friars actively campaigned against those beliefs viewed as "pagan" or non-Christian.

The colonization of Apalachee did not always go smoothly. The proud Apalachee were not wholly willing to do the bidding of Spanish officials. On February 19, 1647, Spaniards in Apalachee gathered at mission Santa María de Bacuqua for a religious celebration. A group of non-Christian Apalachee Indians and Chisca Indians, neighbors of the Apalachee, attacked the Spaniards, killing the Spanish deputy general on duty in the province, his wife, his children, and three friars. Five other friars, aided by mission Apalachee Indians, fled east to Timucua.

The raid sparked a rebellion that soon engulfed Apalachee. Seven of the eight existing missions were destroyed. As soon as word reached St. Augustine, soldiers were sent to Apalachee to quell the disturbance. On the way, they recruited five hundred warriors from the Timucua missions who marched to Apalachee. Arriving there, they faced a huge army—one account says eight thousand warriors—and a fierce battle ensued. The Spaniards fired 2,700 musket balls before running out of shot and opting to retreat to St. Augustine. But the firearms had taken a heavy toll on the Apalachee.

Another troop of Spanish soldiers traveled west from St. Augustine to assess the situation. To their surprise, they found the region quiet and the rebels disbanded. The losses the Apalachee had suffered had caused the Indians to lose heart. The Spaniards marched into Apalachee and demanded the leaders of the rebellion be handed over. Twelve men were hung and twenty-six others sentenced to hard labor in St. Augustine. The Apalachee chiefs again rendered obedience to the crown and the church, and within a year the missions had been rebuilt. Apalachee was once again a Spanish province.

The same Carolinian raids that destroyed the Timucua in the first decade of the eighteenth century also destroyed Apalachee and scattered the native population. Historical accounts of the raids graphically describe Christian Indians at the Apalachee missions being flayed and burned alive. The devastation must have been horrific. Thousands of Apalachee were sold as slaves to work plantations in the Carolinas and the Caribbean. Some Apalachee fled into the forests to

seek refuge, while others moved west to French-controlled Mobile. Eventually, some of those Apalachee moved farther west into Louisiana on the Red River. Descendants of those refugees still live in Louisiana today, the only known relatives of any of the indigenous Florida Indians.

The destruction of the Apalachee and the Timucua missions essentially depopulated north Florida. Some Indians lived around St. Augustine and others around the Spanish settlement at Pensacola. But the damage had been done. The venerable cultures of the Apalachee and Timucua had fallen under the brunt of colonialism.

Mission Indians

Once missions were established among the Timucua and the Apalachee in the first decades of the seventeenth century, it took little time to convert villagers to Catholicism. Initially, friars and Spanish officials worked to convince chiefs to accept Christianity and be baptized. Often the chiefs, their families, and other officials were invited to St. Augustine where they were feted and given gifts as persuasion to accept conversion and to agree to welcome friars into their villages. Once the chiefs converted, it was relatively easy to make converts among their vassals. Children of those first converts, born into Christian families and raised within the mission system, were *de facto* Catholics. Friars replaced native shamans and priests. No longer was there a native belief system with native religious leaders to compete with Catholicism, though beliefs not viewed by the friars as detrimental to the Indians' well being were allowed to persist. At times, Indian children from the missions, especially those slated to become chiefs of their villages, were raised in St. Augustine. By this means, they could be fully indoctrinated to Hispanic and Catholic life and made loyal subjects of the Spanish crown and its minions: the government and church officials living in St. Augustine.

At the missions, the friars educated the Timucua and Apalachee Indians. They were taught to read and write Spanish, and even wrote letters to one another. One friar, Father Francisco Pareja, who administered the mission of San Juan del Puerto on Fort George Island north of Jacksonville, Florida, devised a method of writing the Timucua language using the Spanish alphabet. He translated Catholic devotional books into the native language.

At one mission, Indians learned to play the organ, and at all the mission villages, Christian Indians learned to sing Mass and say morn-

ing and evening prayers. Native novitiates aided the friars as altar boys. Mission Indians celebrated religious festivals, holy days, and the feast days of obligation.

Like Catholics in Spain, the mission Indians received a comprehensive religious doctrine. They learned the Catechism, and, in addition to knowing the Ten Commandments, Seven Deadly Sins, and Fourteen Works of Mercy, could recite the *Pater Noster, Ave Maria,* and *Salve Regina* in Latin. Father Gregorio de Movilla, a Franciscan friar, translated Catholic rites into the Timucua language. A wedding ceremony, performed in the doorway of a mission church, consequently might have been in Latin, Spanish, and Timucua.

The Apalachee and the Timucua became Christian vassals of the Spanish crown, required to work on behalf of the church and the La Florida colony. They no longer were simply Apalachee or Timucua; they were something quite different. They were mission Indians.

Their beliefs were enduring. The Apalachee Indians living in Louisiana today continue to be Catholic.

Indians of the Western Panhandle

Much less familiar than the Apalachee and the Timucua Indians are the native American populations who lived west of the Apalachee in the western Panhandle of Florida. Early Spanish explorers never penetrated that region; the Franciscan missions did not extend west of the Apalachicola River; and missions launched in that drainage were short-lived. Spain did attempt to establish a colony at Pensacola Bay in the mid-sixteenth century, but the colony foundered and failed in only a few years. By the time the Spanish town of Pensacola was founded in the 1690s, great changes already had taken place, and it is not clear that the Indians in the region were the same people who were there in the mid-sixteenth century.

The type of agriculture present in the western Panhandle was not the intensive, cleared-field cultivation practiced by the eastern Fort Walton peoples and their colonial descendants, the Apalachee Indians. Even so, the people of the western Panhandle cultivated corn and other crops to supplement their diet.

One group of western Panhandle Indians was the Chatot, also known as Chacatos, who lived in the upper Apalachicola-Chipola River drainage in Jackson County. In the seventeenth century, some of the Chatot moved into Apalachee where they lived at missions, though they continued to aggressively raid non-Christian Indians. In

1639, the Spanish governor of La Florida sought to end raids between the Chatot, the Amacano, and the Apalachicola Indians. The aboriginal home of the Amacano is uncertain, though in 1674 they were living on the coast, probably somewhere west of the mouth of the Apalachicola River. The Amacano were allies of two other probable western Panhandle groups, the Chine and the Pacara. The Apalachicola Indians, who gave their name to the river, originally may have lived west of that river, moving closer to Apalachee and the Spaniards who offered trading opportunities in the seventeenth century. Franciscan missions established among the Apalachicola Indians did not last long.

The Sawokli Indians (also called Sauocola, Sabacola, or Savacola), lived west of Apalachicola Bay and may have been related to the Apalachicola. Farther west along the coast were the Pensacola Indians. Remnants of these groups may well have merged with other southeastern Indians, including those who coalesced under the Creek Confederacy in the eighteenth century.

Ais Indians and Their Neighbors of the Atlantic Coast

The Ais Indians lived along the Atlantic coast south of the Timucua Indians. Spanish attempts to explore their territory and to place missions there were unsuccessful. Even so, their location on a stretch of coast where Spanish ships sometimes wrecked occasionally drew the attention of St. Augustine officials. As a result, information about the Ais was noted in Spanish documents. Another source of information about the Ais is the Philadelphian Quaker, Jonathan Dickinson. Shipwrecked near Jupiter Inlet in 1696, Dickinson and other survivors made their way north through Ais territory, on to St. Augustine and, eventually, Charleston and then home. Though he continually feared for his life and viewed Ais culture through ethnocentric eyes, Dickinson's account of his adventures remains an informative, firsthand reference about the Ais Indians and others, who lived just to their south.

The Ais probably were made up of a number of loosely allied individual villages or village groups strung out along the coast for nearly 120 miles. Their northern boundary was the small bay situated at the upper end of the Indian River, north of modern Titusville, Florida (west and north of the Kennedy Space Center). That bay was known to the Spaniards and, perhaps, to the native people, as the Bay of Ais. The

Bar of Ais, today part of the Canaveral National Seashore, divided the Bay of Ais from the Mosquito Lagoon. The modern Indian River, a lagoon running parallel to the coast and south past Fort Pierce Inlet to St. Lucie Inlet, was called the River of Ais, suggesting Ais villages were found all the way to modern Martin County. Some Ais may have been associated with the St. Johns culture, while others, especially in southern Brevard County and to the south, were descendants of Indian River culture peoples.

Just below the Ais in coastal Martin County were the Hobe (or Jobe) Indians, whose name is the source of modern Hobe Sound. The Hobe may have been connected to the Ais. Certainly when Jonathan Dickinson was shipwrecked among the Hobe, the Ais chief was able to demand his share of the booty from Dickinson's ship, which had been salvaged by the Hobe. Farther south along the coast in Palm Beach County lived the Jeaga Indians. The Santaluces, so named by the Spaniards and probably an Ais group, lived near modern Port St. Lucie, thought to be the location of a sixteenth-century Spanish garrison christened Santa Lucía. That small and short-lived settlement was established early in the history of the La Florida colony.

The Ais included a number of small towns or groups of towns, each with its own leader, but subject to a single, powerful chief, the chief of Ais. Like other of the central and south Florida Indians, the Ais lived by hunting, fishing, and collecting other wild foods. The bulk of their meat diet, however, came from fish and shellfish. Jonathan Dickinson's account mentions the Indians spearing fish, including drum fish, and gathering oysters and clams. The Ais did some fish-spearing at night from canoes with the aid of torches. Coco plums, sea grapes, and palm berries were among the wild plant foods they collected and ate.

The Ais used gourds as rattles and dippers. These probably were small, hard gourds that grew semi-wild around villages, for as Dickinson specifically notes, the Indians "neither sow nor plant." However, the Indians did have tobacco. It could be that the Ais kept their gardens at inland locations where Dickinson would not have seen them, or perhaps the Ais obtained tobacco by trading with other Indian tribes.

The Ais not only used canoes for fish-spearing, they also attached them together in pairs to form catamarans. Poles tied between two canoes were reinforced with more poles to make a framework, which was then covered with matting to form a floor on which goods and passengers could ride.

Archaeologists have named the archaeological assemblage associated with the Ais and their pre-Columbian ancestors the Indian River culture, recognizing that it is related both to the St. Johns culture of northeast Florida and the archaeological culture(s) of the south Florida Atlantic coast. Indian River culture sites have been found inland among the marshy headwaters of the St. Johns River in Brevard, Indian River, and northern St. Lucie counties. Those freshwater wetlands are only ten to fifteen miles from the coast, and it is likely that Ais Indians and related groups lived there as well as on the coast. Perhaps people moved between locations, taking advantage of whichever foodstuffs could be garnered at specific times.

One of the Ais towns where Jonathan Dickinson stopped in 1696 was Jece, four to five miles north of Ft. Pierce Inlet on the Indian River. He notes that the chief's house measured twenty-four by forty feet, with palm-thatched walls and a roof. Low benches formed seating platforms within the partitioned interior. By contrast, the villagers occupied simpler wigwam-like houses. These were made by sticking poles into the ground, bending them over, tying them together, and thatching the framework with palm fronds. Some houses were built atop shell heaps. Those houses kept Dickinson and the members of his party dry when a wind-driven high tide inundated lower-lying houses.

At the town of Hobe on the south end of Ais territory, Dickinson noted that the men wore loincloths made of woven vegetable fibers. The long hair of the men was "tied in a roll behind [their heads] in which stuck two bones shaped one like a broad arrow, and the other a spear point." The latter were probably bone hairpins like those found at archaeological sites throughout Florida. After salvaging trunks from Dickinson's wrecked ships, both Hobe men and women were quick to put on the passengers' clothes.

Dickinson's viewed the Indians as savages as his description of an Indian ceremony reflects:

Night came on; the moon being up, an Indian, who performeth their ceremonies stood out, looking full at the moon making a hideous noise, and crying out acting like a mad man for the space of half an hour; all the Indians being silent till he had done: after which they all made fearful noise some like the barking of a dog, wolf, and other strange sounds. After this, one gets a log and sets himself down, holding the stick or log upright on the ground, and several others getting about him, made a hideous noise, singing to our amazement; at length their women joined consort making the noise more terrible. This they continued till midnight.

At another native village north of Hobe, perhaps at St. Lucie Inlet, Dickinson watched the Indians brew and drink black drink, the same beverage called cassina which was made by the Timucua Indians and which Theodore de Bry depicted in one of this 1591 engravings. Dickinson wrote:

> In one part of this house where the fire was kept, was an Indian man, having a pot on the fire wherein he was making a drink of the leaves of a shrub (which we understood afterwards . . . is called caseena), boiling the said leaves, after they had parched them in a pot; then with a gourd having a long neck and at the top of it a small hole which the top of one's finger could cover, and at the side of it a round hole of two inches diameter, they take the liquor out of the pot and put it into a deep round bowl, which being almost filled containeth nigh three gallons. With this gourd they brew the liquor and make it froth very much. It looketh of a deep brown color. In the brewing of this liquor was this noise made which we thought strange; for the pressing of this gourd gently down into the liquor, and the air which it contained being forced out of the little hole at top occasioned a sound; and according to the time and motion given would be various. This drink when made, and cooled to sup, was in a conch-shell first carried to the Casseekey [cacique or chief], who threw part of it on the ground, and the rest he drank up, and then would make a loud He-m; and afterwards the cup passed to the rest of the Casseekey's associates.

Dickinson's descriptions of the Ais Indians, though colored by his own fears and beliefs, are still a rich account filled with extraordinary tidbits of information. It is ironic that his late seventeenth-century misfortune—being shipwrecked—is such a boon for early twenty-first-century artists and students of the Florida Indians.

Mayaca and Jororo Indians of Central Florida

East of the Ais from Lake George, south along the St. Johns River and its many lakes for an unknown distance, probably at least into Seminole County, lived the Mayaca Indians. Shortly after the founding of St. Augustine in 1565, Pedro Menéndez de Avilés, first governor of the La Florida colony, led an expedition south up the St. Johns River to explore and to make contact with the many Indians living there. After crossing Lake George, the expedition arrived at one of the Mayaca villages, but found it abandoned: probably a deliberate withdrawal strategy by the Indians, who were uncertain of the Spaniard's intentions. After the Spaniards and the Indians made contact, the Mayaca

indicated to Menéndez that the Spaniards' boats should not proceed any farther up river.

Initially Menéndez refused to retreat and continued on, but soon found the Mayaca had placed a row of stakes in the river, thwarting his advance. The Spaniards broke down the barricade and continued. But the river then narrowed, putting the Spaniards in easy reach of bows and arrows shot by the Mayaca from shore. After negotiations failed, Menéndez retreated.

A Spaniard named Perucho, a former captive of the Ais who served Menéndez as interpreter and guide, helped convince the Spanish governor that he'd made the proper decision, telling him the Mayaca were "many and very warlike." The Mayaca were said to control the river from the point where the confrontation with Menéndez took place south up the river for an unspecified distance.

Little is known about individual villages within Mayaca territory. At least one village site may have been abandoned by the late mission period when Spanish soldiers traveled to "ancient Mayaca" on their way to pacify the native people following a 1696 rebellion against three Spanish missions, which recently had been placed in central Florida. Spanish colonial historian John H. Hann suggests ancient Mayaca may be where the first Mayaca mission of San Salvador was located in the early seventeenth century.

Often mentioned along with the Mayaca in Spanish documents were the Jororo Indians, thought to reside southwest of the Mayaca and west of the Ais, in the region from Orange County south into Osceola County and, perhaps, into parts of Polk and Highland counties. To get to the Jororo, the Spaniards traveled down the St. Johns River to Mayaca and then went overland. The Jororo and the Mayaca are often mentioned together in Spanish documents. The basis for this linkage is language; both groups spoke a language, which the Spaniards called Mayaca.

In the 1690s, with the population of the Timucua missions slipping to only a few hundred, the Spaniards looked southward to the Jororo and Mayaca as a new field for Franciscan missionaries and a new source of labor for the La Florida colony. Documents from that missionary effort mention several Jororo towns: Jororo itself, Atissimi, Atoyquime, and Piaja. Missions, none of which lasted more than a few months, were placed in the first three of the towns. Hann has observed that the name Atissimi (also Jizime and Tisime), could be the source of the name of Kissimmee, the latter perhaps from a Seminole Indian pronunciation of Atissimi.

In 1693, a Franciscan friar noted that the Jororo and Mayaca Indians "on the whole do not work at plantings. They are able to sustain themselves solely with the abundance of fish they catch and some wild fruits." Like the Ais Indians, they lived by hunting, gathering, and fishing.

Indians of South-Central Florida and the Lake Okeechobee Basin

South of the Jororo in the lower Kissimmee River Valley and in the Lake Okeechobee Basin were many Indians, colonial period descendants of the Belle Glade people, who, as we have seen, were living there as early as 500 B.C. The Indians of that region were far beyond the reach of Spanish soldiers or Franciscan friars, and they remained relatively isolated from European contact, receiving little mention in contemporary historical documents.

One source of information about the Indians living around Lake Okeechobee is Escalante Fontaneda, a Spaniard shipwrecked in south Florida about 1545 when he was ten years old. Fontaneda lived among the Calusa Indians until 1566 when he was found and taken back to St. Augustine by Pedro Menéndez. Fontaneda wrote an account telling what he knew of the Indians in south Florida, apparently intended as a source of information for Menéndez and other Spaniards. In his narrative, he notes that there were many little villages around Lake Okeechobee, which he calls the Lake of Mayaimi, including one called Guacata, another Mayaimi, and others Cutespa, Tavagemve, Tomsobe, and Enenpa.

The relationship between these interior Indian settlements and the powerful Calusa Indians on the southwest Florida coast is poorly understood. One Spanish account from the sixteenth century suggests the interior villages were vassal to the Calusa chief. However, many items, including precious metals, all of which were salvaged from wrecked ships along Florida's coasts, have been found in archaeological sites around Lake Okeechobee. The Indians in that region must have had sufficient military or economic clout to obtain the objects from coastal south Florida Indians who had salvaged them from the wrecks.

Even though the Indians around Lake Okeechobee lived well apart from the missions and other Spanish settlements in north Florida, the same diseases that hit the Timucua and Apalachee must have reached

them as well. Epidemics and raids by Indians from north of Florida following the demise of the north Florida missions devastated the Guacata, Mayaimi, and other Indians of central and southern Florida.

Indians of Greater Tampa Bay

An automobile journey south though Pinellas County on U.S. Highway 19 to Manatee County can leave a very false impression of the total amount of coast line and wetlands which exist in that west-central Florida region. Indeed, were one to measure the exact indented coastline from Clearwater to Bradenton the result would be many times the distance traveled by car. For one thing, there is Tampa Bay and its two northern lobes, Old Tampa Bay and Hillsborough Bay, each of which harbors many inlets, bays, and islands. The same is true of the Gulf coast proper. Numerous rivers also flow into Tampa and the other bays, including the Hillsborough, Alafia, Little Manatee, and Manatee rivers—all of which drain freshwater wetlands in Pasco, Hillsborough, Polk, and Manatee counties.

Today, many of the wetlands have been drained, ditched, and dyked, making it difficult to see them. In places, seawalls extend to the water's edge, and marshes and mangrove forest that once hugged the shoreline have been removed. The region hardly resembles the sixteenth-century land and seascapes observed by the expedition of Hernando de Soto when he explored Tampa Bay and established a base camp on its southeastern shore. At the time, the greater Tampa Bay region was a huge estuary, one teeming with fish and shellfish.

Given the natural bounty, it is no surprise that Tampa Bay was home to Florida Indians whose ancestors had lived there for thousands of years. Evidence of their settlements—the large shell middens and mounds of the Safety Harbor, Weeden Island, and earlier cultures—once covered the shorelines of the coast and the bays. Though many of those relics have been destroyed and the shell used to pave the roads of nineteenth-century towns like Tampa and Bradenton, a few still exist, preserved within county, state, and federal holdings where they can be visited by the public.

Spanish accounts describing the 1539 Hernando de Soto expedition and an expedition led by Pedro Menéndez de Avilés to Old Tampa Bay in 1566 mention several Indian groups living around the bay shoreline: Uzita, Mocoso, Pohoy, and Tocobaga Indians. In the next century, the Alafaias also are mentioned as Tampa Bay–region Indians.

Each of these groups was a small chiefdom consisting of a major town and several additional settlements, including some that may have been inland. De Soto's men established their first camp in Florida among the Uzita Indians on the Little Manatee River. They also traveled through the territory of the Mocoso Indians just to the north on the east side of Hillsborough Bay.

None of the Spanish accounts of the Tampa Bay Indians mentions any type of gardening, and the de Soto expedition specifically notes that the first corn fields they saw after marching north of Tampa Bay were well north of the bay, probably near modern Dade City. Though the earlier Narváez expedition saw corn at an Indian village on the north end of Tampa Bay, they were aware that it came from fields ten to twelve leagues north, which would put them at about the same location, Dade City. The Indians of Tampa Bay were not farmers.

Sixteenth-century Spaniards provide firsthand accounts of what the villages and houses of the Uzita and other Tampa Bay Indians were like. One describes the town of Uzita itself as consisting of "seven or eight houses, built of timber, and covered with palm-leaves. The Chief's house stood near the beach, upon a very high mound. . . . at the other end of the town was a temple, on the top of which perched a wooden fowl [a carving] with gilded eyes." These accounts also contain information about the Uzita's use of a charnel house where bones of the dead were stored.

When de Soto marched north from Tampa Bay, he left a portion of his army behind at the camp at Uzita for several months. Interactions between the Spaniards and the Indians could only have been detrimental to the Uzita. Indian men were taken captive to serve as bearers for the expedition; women were made to serve as consorts; and Indian food supplies were commandeered to feed the army. Some Indians were killed in skirmishes, and diseases—probably passed from the soldiers and their animals to the Indians—resulted in the deaths of many more. It may be no coincidence that the name of the Uzita disappears from historical records by the end of 1539, when the Spaniards left the region. As it was for the Timucua Indians living around Fort Caroline and St. Augustine, contact with Europeans in the sixteenth century must have been the cause of their demise. The Uzita may have the dubious distinction of being the first of the Florida Indians to be annihilated under the juggernaut of colonialism.

By the first decades of the 1700s, the Tampa Bay Indians had suffered grievously. Remnants of the Tocobaga and the Pohoy had fled to villages near St. Augustine where they sought protection, with other

refugees, from marauding Indian raiders of the north. Another group of Tocobaga moved north to the fringe of Apalachee near the mouth of the Wacissa River.

At the time of Pedro Menéndez' sixteenth-century foray into Old Tampa Bay, the main village of the Tocobaga was near Safety Harbor, Florida. At one point, the chief of the Tocobaga was able to assemble twenty-nine vassal chiefs and 1,500 warriors to greet the Spaniards. But just over a century later, this once-powerful chiefdom was reduced to remnants, some of whom lived far from their homeland.

Calusa Indians

The Calusa Indians, like their ancestors of the Caloosahatchee culture, lived in a water world on the southwest Florida coast. Their villages, like those of pre-Columbian times, blanketed the shorelines and islands of Charlotte Harbor, Pine Island Sound, San Carlos Bay, and Estero Bay in Charlotte and Lee counties.

Like the Apalachee Indians of northwest Florida, the sixteenth-century Calusa were subject to a paramount chief to whom other village chiefs were vassals. The residence of the chief and members of his ruling family was at the town of Calos on Mound Key in Estero Bay, south of Fort Myers and Cape Coral, Florida. The Mound Key site is a circular island cross-cut by a Calusa-built canal and punctuated with shell middens and shell and earth mounds that were the bases for temples and other important buildings. One of the mounds is over thirty feet high.

The power and splendor of the Calusa chief led the Spaniards to call him *el Rey*, the king. He was a powerful individual whose vassal chiefs presented him with feathers, hides, mats, food, and captives as tribute. They also brought him items salvaged from wrecked ships, including victims of those wrecks: Spanish men and women, as well as Indians from South America who had been aboard.

In the sixteenth century, the Calusa chief's hegemony extended over much of south Florida. Escalante Fontaneda, one of those shipwreck victims, wrote about the geographical extent of the chief's power, naming Indian towns around Lake Okeechobee and on the Gulf and Atlantic coasts as Calusa vassals. Some of those latter towns are Tanpa (at the mouth of Charlotte Harbor), Juchi (between Tanpa and Calos), Muspa (on Marco or Horrs Island at the northern end of the Ten Thousand Islands), Tatesta (Tequesta, at the mouth of the Miami River), and Yobe (Hobe, on the Atlantic coast).

Like other of the central and south Florida Indians, the Calusa re-
lied heavily on fish and shellfish for their sustenance. The southwest
Florida coast, especially the shallow inshore waters of the harbors and
bays, were particularly bountiful and provided a dependable source of
food, one as rich as that derived by other southeastern Indians from
agriculture. As a result, the Calusa had a relatively densely distributed
population and were organized as a complex chiefdom, much like the
Apalachee Indians. They also had a rich religious life, one remarked
on by Spaniards both in the sixteenth century, when Pedro Menéndez
established a short-lived Jesuit mission and garrison on Mound Key,
and at the end of the seventeenth century, when Franciscan friars were
rebuffed in their attempt to put a second mission at Calos. At that
time, the Calusa capitol was still on Mound Key, and the friars noted
that the Indians continued to employ wooden masks in their ceremo-
nies.

The Calusa, still flourishing in the 1690s, soon suffered the same
early eighteenth-century Indian raids that wiped out other of the Flor-
ida Indians. To seek succor, as well as to secure trade goods, Calusa
chiefs and some of their vassals traveled to Cuba in 1710, but many of
them died from diseases. Later still, others moved to Cuba. Eventually
the Calusa were pushed south out of their traditional lands, down into
the Florida Keys. It is likely that some of the Indians worked for Cu-
ban fishermen, who sailed the Florida coasts, netting and drying fish
to take to Cuban markets.

The twin scourges of disease and raids by Indians moving into Flor-
ida quickly decimated the Calusa. By the middle eighteenth century
they had ceased to exist as a people. Some refugees may have contin-
ued to live in southern Florida after the Spanish left St. Augustine, but
if so, there is no historical account of them. Like the Ais, Hobe, Uzita,
and Guacata, the Calusa were crushed under the European conquest of
the Americas.

Tequesta Indians

Juan Ponce de Leon, who anchored in Biscayne Bay in 1513, was the
first European to reach that locality. He would have a difficult time
recognizing it today. Though the Miami River continues to flow into
the bay, it has been tamed by numerous seawalls and is fronted along
almost its entire length through the city by buildings of all shapes and
sizes. Forests of mangroves are gone from the shores of the bay and the
mainland. The hundreds of shell middens and mounds that once dot-

ted the landscape, including Miami Beach, have given way to high-rise hotels and apartments. Evidence of the Tequesta Indians and their pre-Columbian Glades culture ancestors is scarce in modern Miami-Dade County. Even so, the past occasionally shines through when land clearing uncovers an archaeological site, as it did several years ago on the south bank of the mouth of the Miami River. There, beneath newly razed apartment buildings, archaeologists became reacquainted with the Brickell Point archaeological site, which disappeared in 1950 when the apartments were built.

Today, Miami is a crossroads between North Americans and the people of South and Central America and the Caribbean. Its unique position near the end of peninsular Florida similarly drew Europeans in the sixteenth century; it was a convenient stopping-off place for ships sailing from the south to the north, and vice versa. An account of Juan Ponce de Leon's 1513 voyage to La Florida mentions the Tequesta. Their village is also marked on a circa 1514 Italian map thought to depict Indian villages and other places on Florida's coast visited by Juan Ponce. A later sixteenth-century Spanish geographer pinpoints the main village of the Tequesta Indians on the north side of the Miami River near its mouth, across from the Brickell Point site. At one time, the north bank of the river at that location, like the south bank, was covered with shell middens.

The Miami River may have provided Spanish ships with a source of fresh water. If so, mariners would have anchored their ships off the mouth of the river in Biscayne Bay and lowered small boats carrying casks. Sailors then could row the smaller boats upriver beyond the reach of brackish water to fill the casks.

The strategic location of Tequesta and the erroneous belief that the Miami River could be traversed all the way to Lake Okeechobee, thought to connect in turn with the St. Johns River, led Pedro Menéndez to place a small outpost there in the 1560s. This garrison included a Jesuit priest who sought to convert the Tequesta Indians to Christianity, thus making them allies of the Spaniards. It was hoped they would offer aid to Spanish shipwreck victims on that stretch of Florida's coast.

Tequesta's location and the former presence of a Spanish outpost there, however short-lived, has given the Tequesta Indians a historical prominence which probably far outstrips their relative importance in south Florida. Other groups in southeast Florida, like the Santaluces and Bocaratones, may once have been as numerous as the Tequesta; but they received much less attention in historical documents, lead-

ing to a lack of information about them and, consequently, less notice by modern researchers. This is the conundrum that faces artists and archaeologists alike when dealing with the Indians of Florida, especially those people who occupied much of the southern part of the state. We know so little about so many people. Worse, many Indians never got their names into any documents at all, and, consequently, have been lost forever to history. Whole towns and ethnic populations may once have existed, and we will never know it.

The Tequesta were ruled by a chief whose clan held high status. He was, in turn, a vassal of the more powerful Calusa chief. This alliance was in part cemented by marriages among chiefly families or clans. Important to the governance of the Tequesta were people described as leading men, perhaps village elders. Pedro Menéndez took some of these important Tequesta with him to Spain. One later was returned home, presumably with stories about the Iberian peninsula as fantastic as those the Spaniards took back to their homes about the Florida peninsula.

The Tequesta and the other Indians of southeast Florida were never as numerous or as densely distributed as the Calusa Indians. Nor was their society as complex, with a paramount chief and vassal chiefs. For one reason, the environment of the Tequesta was simply not as bountiful as that of the Calusa. Though fish and shellfish were readily available from the inshore waters of Biscayne Bay, the estuaries of southwest Florida, with their large populations of fish, whelks, and other mollusks, are not found in Dade County.

In 1742, Jesuit missionaries arrived at the former site of Tequesta to administer to the Indians living there at the time, refugees from the raids that had engulfed southern Florida. Documents pertaining to mission Santa María de Loreto, as it was christened, do not mention the Tequesta. It is likely that disease and raids had decimated them by that time and that any survivors had joined refugee groups like the Bocaratones, then living at the old Tequesta village.

Shell middens and mounds associated with an archaeological assemblage similar to that of the post-A.D. 800 Glades culture are present in the Florida Keys, though, like Glades sites in southeast Florida, they have been severely impacted by modern development. In the colonial period, Spanish documents mention several Indian towns in the Keys. The chief of the most important group was Chief Matecumbe, whose name was given to modern Upper and Lower Matecumbe Keys. A sixteenth-century Spanish account mentions two other Indian towns in the Keys, Cuchiaga and Guarugunbe, and an-

other, Tancha, is noted in a different document. The hegemony of the Calusa chief reached all the way into the Keys, or so the shipwrecked Spaniard Escalante Fontaneda was led to believe.

During the early eighteenth century, the Keys served as a refuge for south Florida Indians trying to escape the raiding parties who were decimating their traditional villages. Their ultimate fate, like that of so many of the south Florida Indians, is poorly known.

5 FLORIDA INDIANS TODAY

In 1763–64, nearly two centuries after the founding of Spanish St. Augustine, Spain withdrew from its La Florida colony, ceding what would one day be the twenty-seventh of the United States of America to Great Britain. Less than one hundred Indians living in St. Augustine and at two nearby mission villages, one of which was Nombre de Dios, went to Cuba with the departing Spaniards. Some were descendants of the Indians who had fled to St. Augustine after the Carolinian raids of the early eighteenth century; others were refugees from elsewhere in the state; and still others were Indians who had moved into Florida during the tumultuous times following destruction of the Timucua and Apalachee missions.

About the same number of Indians living in and around the Spanish town of Pensacola also left that settlement with the Spaniards, all of whom moved to Veracruz. Finally, as mentioned in chapter 4, a small number of Florida Indians were living at this time in southern Florida, including in the Keys. At least some of the Keys' Indians worked for Cuban fisherman who maintained fishing ranchos along the Florida coasts where fish, netted from boats, were cleaned and dried in preparation for export to Cuba. These Indians included women, married to Cubans, and their families. Some Indian fishermen probably accompanied the fishing vessels back and forth to Cuban ports and were well acquainted with Hispanic life. After the fall of La Florida, the Cuban fishermen continued to ply the coasts of southern Florida, much as they had done in earlier times.

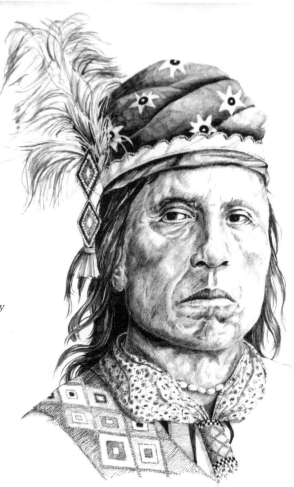

Seminole Warrior.

This drawing portrays a Seminole member in traditional tribal garb of the nineteenth century. I based his clothing on contemporary paintings and drawings of Seminole warriors and on objects housed in museum collections.

Other south Florida Indians also were acquainted with the world beyond. Some had been back and forth between the Keys and Havana, and many were engaged in trade with Cubans. After Florida became a British colony, they might well have continued the same pursuits.

At most, all of the south Florida Indians probably numbered no more than a hundred or so at this time. By the end of 1764, Florida's indigenous peoples essentially were gone, victims of diseases, slave raids, and warfare. As populations plummeted and societies fragmented, birth rates had dropped. The Florida Indian population was never able to rebound. Estimated at 350,000 in 1492, the number of Indians living in Florida was fewer than 350 people less than three centuries later. Of these remnant Indians, most had been pushed into St. Augustine, Pensacola, or the Florida Keys, and from these areas made their final exits. If any descendants of the original Florida Indi-

ans still remained in Florida apart from these locales, their numbers were so small as to be insignificant.

The Creek Indian Migration

This population vacuum, as well as Florida's bounty—hunting lands, wetlands, fertile fields previously cleared for Spanish and mission Indian agriculture, and herds of feral cattle left behind from Spanish ranching—provided opportunities for Indian migrants from the north. Some of those same Indians might well have been among the groups raiding the Florida Indians only decades before. Beginning about 1750, small numbers of these newcomers settled in the old mission provinces. Some chiefs of the new towns ventured into St. Augustine to pledge allegiance to the Spanish officials and receive gifts, just as Timucua chiefs had done 150 years earlier.

Most of the new Florida Indians were Lower Creek Indians from Georgia and Alabama, who had moved into the Tallahassee–Lake Miccosukee locality, formerly part of Apalachee, and into the Gainesville–Paynes Prairie region where missions had served Timucua-speaking Potano Indians. Both areas had been the locations of Spanish ranches. Creek towns also were founded in the Apalachicola River drainage and west of Gainesville near the lower Suwannee River.

Spanish officials welcomed the Creeks. The collapse of the mission system in Apalachee and Timucua had left the colonists without native allies who could aid them against the growing British colonial presence in the Carolinas and Georgia. One term used by the Spaniards to refer to the Florida Creek was *cimarrones*, a word used throughout the Americas by Spaniards for non-Christian Indians living apart from Spanish settlements. *Cimarrone* is the source of the word *maroon*. As pronounced by the Creeks, ci-marr-on-e became se-mi-no-les. Over the next few decades, as the Florida Creek began to act independently of the Creek settlements they had left behind, they began to develop a new identity: they were Seminole Indians.

Seminole Indians

In Florida, some of the Seminoles—such as those at the town of Cuscowilla near Paynes Prairie, who were led by the famed Chief Cowkeeper—kept herds of cattle, probably animals descended from

the cattle which had been reared on Spanish ranches around the prairie. The Seminole Indians also hunted and fished and grew corn, beans, squashes, tobacco, and other crops. They traded those and other goods—honey, cow and deer hides—to Spaniards and later to British traders for manufactured goods. Much more than the earlier mission Indians, the Seminoles had access to a host of such items.

A distinctive Seminole way of life emerged. Even so, the Seminole continued to share many beliefs and endeavors with their Creek neighbors. They played the traditional stickball game and smoked the calumet, drank black drink in purification rituals, and celebrated the Busk or Green Corn festival. Though Britain returned Florida to Spain in 1783, the Seminoles continued to traffic with traders from Georgia and the Carolinas.

Events taking place outside Florida's borders continued to impact the Indians living in the state, even as they had done in the seventeenth and eighteenth centuries. In the early 1800s, as many as a thousand Upper Creek Indians moved into Florida following Andrew Jackson's 1814 defeat of Upper Creek warriors at the Battle of Tohopeka in Alabama—one of Jackson's many maneuvers to take land from southeastern Indians and give it to American settlers.

The removal of thousands of Creek Indians from Georgia and Alabama in the 1830s and 1840s and their resettlement west of the Mississippi River led to the movement of still more Creeks into Florida. By the early 1830s, several thousand Indians made their homes in the state, by then a territory of the United States of America. Florida also had a population of Maroons, black people who had fled south into Florida to escape slavery on the plantations of other southeastern states and who allied with the Seminoles.

The same opportunities that drew the Indians into Florida also were attractive to Anglo settlers from Georgia, the Carolinas, and elsewhere. Even before Florida gained statehood in 1845, friction between the Seminole Indians and Anglo settlers living in close proximity to one another led to skirmishes and open conflict. Fueled by the federal government's anti-Indian policies and by fears of Indian and Maroon attacks, the Anglos pushed to move the Seminoles out of northern Florida. Under the 1823 Treaty of Moultrie Creek, some of the Seminole leaders agreed to move onto lands in interior central Florida, from about Ocala south to Lake Okeechobee.

But that was not enough for a land-hungry nation. Newly elected president, Andrew Jackson, supported the 1830 Indian Removal Act, which called for all Indians, including the Seminoles, to be moved west of the Mississippi River. Five years later, war broke out between

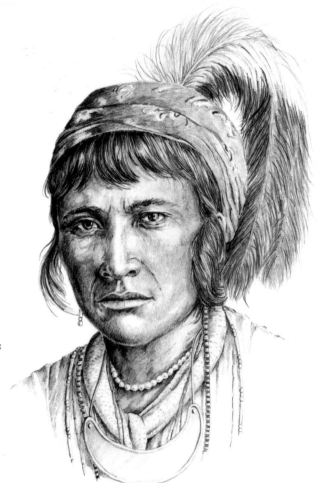

Osceola (Seminole tribe).

This drawing embodies my concept of the famous Seminole leader, Osceola, in the 1830s. I tried to capture his directness and intelligence. After Osceola's capture by the United States Army in late 1837, and before he died in late January, 1838, several portraits of him were painted.

the U.S. federal government and the Seminoles. During the seven years before the conflict ran its course, many Seminoles were captured and moved west, while others went voluntarily. It is estimated that by the end of 1842, only a few hundred Seminole Indians remained in Florida, all living in the isolated Everglades and other wetlands of southern Florida.

The southward push of settlers again created another open conflict in 1855. This Third Seminole War dragged on for three years. The monetary cost to the still-young American nation was tremendous, though only 150 Seminoles were captured or surrendered and forced to move west. The migration left several hundred Indians still in south Florida. The Seminoles living in Florida today are the descendants of those Indians.

From the 1850s to the 1950s, the Seminoles continued to make their livelihood in south Florida. Then in the 1950s, federal legislation was passed which forced the Seminole Indians and other tribes in the United States to incorporate as federally recognized entities. On August 21, 1957, many of the Seminoles voted to become the Seminole Tribe of Florida. Five years later, others joined together as a second federally recognized group, the Miccosukee Tribe of Florida.

Indians in the Twenty-first Century

By no means are the Seminole and Miccosukee Indians the only Florida Indians. In the 2000 U.S. census, 52,541 people (out of nearly sixteen million total Florida residents) identified themselves as American Indians (or Alaskan natives, of which there were fewer than 1,000). Of that number, less than five percent are listed as affiliated with the Seminole and Miccosukee tribes. Who are the more than nearly 50,000 other Indians living in Florida? Some are Creek Indians, descendants of the Creeks who stayed behind when their relatives and neighbors were forced in the nineteenth century to leave their homes in Alabama and Georgia and move west. Other Indians in Florida are identified as representatives of nearly 135 other tribes (not counting about fifteen Alaskan native groups). At least one member of nearly every tribe you have ever heard of lives in Florida, from Apache to Yurok. The tribe with the largest number of individuals is the Cherokee. Cherokee Indians in Florida number just over ten thousand individuals. If specific reservations or communities are tallied—Chiricahua Apache or Mescalero Apache, rather than just Apache, for example—the number of American Indian groups represented is an astounding 350!

Are there really 53,541 Indians living in Florida, or has the actual number been inflated by people who simply want to identify with American Indians? No one knows for certain. It is true that since 1900 the number of Indians living is Florida has steadily increased, though from 358 in 1900, the number only grew to 1,011 by 1950. But the last fifty years have seen a phenomenal increase as the state's population has grown: from 6,671 Indians in 1970; to 19,316 in 1980; 36,335 in 1990; and 53,541 in 2000. In the 2000 census even more Floridians, a total of 121,384, reported they were either of Indian descent or were of mixed Indian and other ancestry. That means one of every 130 Floridians trace one or more of their ancestors to an American Indian tribe.

It is very gratifying that Florida once again has a significant population of people who are American Indians and many more who are of Indian ancestry. Though the lives of the Seminole, Miccosukee, and other Indians in Florida are very different from those of their ancestors who lived in the United States hundreds of years ago, the same is true of all Floridians.

Many of Florida's tribes have been lost. But others have been found. Our Indian heritage, a historical and cultural legacy shared by sixteen million Floridians, should be remembered and respected by all.

SUGGESTED READINGS

On the Jacques Le Moyne and
Theodore de Bry Depictions of Florida Indians

Duchet, Michèle. "Les Floridiens de J. Le Moyne de Morgues ou les pièges de la Représentation." In *Figures de l'Indien*, edited by Gilles Thérien, 331–44. Montréal: l'Université du Québec, 1995.

Faupel, W. John. "An Appraisal of the Illustrations." In *A Foothold in Florida, The Eye-Witness Account of Four Voyages made by the French to that Region . . .* , translated by Sarah Lawson, 150–78. East Grinstead, West Sussex, England: Antique Atlas Publications, 1992.

Feest, Christian F. "Jacques Le Moyne Minus Four." *European Review of Native American Studies* 1, no. 1 (1988): 33–38.

Lestringant, Frank. *Le Brésil d'André Thevet: Les Singularitiés de la France Antarctique.* 1557. Paris: Éditions Chandeigne, 1997.

Lorant, Stefan. *The New World, the First Pictures of America.* New York: Duell, Sloan and Pearce, 1946. [Second edition, 1952.]

Schlesinger, Roger, and Edward Benson. *Portraits from the Age of Exploration: Selections from André Thevet's Les vrais poutraits et vies des hommes illustres.* Urbana: University of Illinois Press, 1993.

Staden, Hans. *Hans Staden: The True History of His Captivity.* Edited and translated by Malcolm Letts. London: George Routledge and Sons, 1928.

Sturtevant, William C. "The Ethnological Evaluation of the Le Moyne–De Bry Illustrations." Vol. 1 of *The Work of Jacques Le Moyne de Morgues, a Huguenot Artist in France, Florida and England,* by Paul Hulton, 69–74. London: British Museum Publications, 1977.

———. "First Visual Images of Native America." Vol. 1 of *First Images of America,* edited by Fredi Chiapelli, 417–54. Berkeley: University of California Press, 1976.

———. "The Sources for European Imagery of Native Americans." In *New World of Wonders: European Images of the Americas, 1492–1700,* edited by Rachel Doggett, 25–33. Washington, D.C.: Folger Shakespeare Library, 1992.

———. "La 'Tupinambisation' des Indiens d'Amérique du Nord." In *Figures de l'Indien,* edited by Gilles Thérien, 345–62. Montréal: l'Université du Québec, 1995.

On Florida's Ancient Indians and the Ancestors of the Lost Tribes

Brown, Robin C. *Florida's First People: 12,000 Years of Human History.* Sarasota: Pineapple Press, 1994.

Cushing, Frank H. *Exploration of Ancient Key-Dweller Remains on the Gulf Coast of Florida.* 1896. Gainesville: University Press of Florida, 2000.

Daniel, Randolph, Jr., and Michael Weisenbaker. *Harney Flats: A Florida Paleo-Indian Site.* Farmingdale, N.Y.: Baywood Publishing, 1987.

Doran, Glen H. *Windover: Multidisciplinary Investigations of an Early Archaic Florida Cemetery.* Gainesville: University Press of Florida, 2002.

Gilliland, Marion S. *The Material Culture of Key Marco, Florida.* Gainesville: University Press of Florida, 1975.

Goggin, John M. *Space and Time Perspective in Northern St. Johns Archeology, Florida.* Gainesville: University Press of Florida, 1998.

Griffin, John W. *Archaeology of the Everglades.* Gainesville: University Press of Florida, 2002.

Hutchinson, Dale L. *Bioarchaeology of the Florida Gulf Coast: Adaptation, Conflict, and Change.* Gainesville: University Press of Florida, 2003.

Larsen, Clark Spencer. *Bioarchaeology of Spanish Florida: The Impact of Colonialism.* Gainesville: University Press of Florida, 2001.

McGoun, William E. *Prehistoric People of South Florida.* Tuscaloosa: University of Alabama Press, 1993.

Milanich, Jerald T. *Archaeology of Precolumbian Florida.* Gainesville: University Press of Florida, 1994.

———. *Florida's Indians from Ancient Times to the Present.* Gainesville: University Press of Florida, 1998.

Milanich, Jerald T., and Ann S. Cordell, Brenda J. Sigler-Lavelle, Tim A. Kohler, and Vernon J. Knight Jr. *Archaeology of Northern Florida, A.D. 200–900: The McKeithen Weeden Island Culture.* Gainesville: University Press of Florida, 1997.

Miller, James J. *An Environmental History of Northeast Florida.* Gainesville: University Press of Florida, 1998.

Purdy, Barbara A. *The Art and Archaeology of Florida's Wetlands.* Boca Raton: CRC Press, 1991.

———. *Florida's Prehistoric Stone Tool Technology.* Gainesville: University Press of Florida, 1981.

Sears, William H. *Fort Center: An Archaeological Site in the Lake Okeechobee Basin.* Gainesville: University Press of Florida, 1994.

Weitzel, Kelley G. *Journeys with Florida's Indians.* Gainesville: University Press of Florida, 2002.

Widmer, Randolph E. *The Evolution of the Calusa: A Nonagricultural Chiefdom on the Southwest Florida Coast.* Tuscaloosa: University of Alabama Press, 1988.

Willey, Gordon R. *Archeology of the Florida Gulf Coast.* Gainesville: University Press of Florida, 1998.

On the Lost Tribes

Boyd, Mark F., Hale G. Smith, and John W. Griffin. *Here They Once Stood: The Tragic End of the Apalachee Missions.* Gainesville: University Press of Florida, 1999.

Dickinson, Jonathan. *Jonathan Dickinson's Journal; or God's Protecting Providence. . . .* 1699. Edited by Charles McL. Andrews and Evangeline W. Andrews. Stuart, Fla.: Valentine Books, 1975.

Ewen, Charles R., and John H. Hann. *Hernando de Soto Among the Apalachee: The Archaeology of the First Winter Encampment.* Gainesville: University Press of Florida, 1998.

Hann, John H. *Apalachee: The Land between the Rivers.* Gainesville: University Press of Florida, 1988.

———. *History of the Timucua Indians and Missions.* Gainesville: University Press of Florida, 1996.

———. *Indians of Central and South Florida, 1513–1763.* Gainesville: University Press of Florida, 2003.

———. *Missions to the Calusa.* Gainesville: University Press of Florida, 1991.

Hann, John H., and Bonnie McEwan. *San Luis and the Apalachee Indians.* Gainesville: University Press of Florida, 1998.

MacMahon, Darcie A., and William H. Marquardt. *The Calusa and Their Legacy: South Florida People and Their Environments.* Gainesville: University Press of Florida, 2004.

McEwan, Bonnie G., ed. *Spanish Missions of La Florida.* Gainesville: University Press of Florida, 1993.

McGoun, William E. *Ancient Miamians: The Tequesta of South Florida.* Gainesville: University Press of Florida, 2002.

Milanich, Jerald T. *Florida Indians and the Invasion from Europe.* Gainesville: University Press of Florida, 1995.

———. *Laboring in the Fields of the Lord, Spanish Missions and Southeastern Indians.* Washington, D.C.: Smithsonian Institution Press, 1999.

———. *The Timucua.* Oxford, UK: Blackwell Publishers, 1996.

Milanich, Jerald T., and Charles Hudson. *Hernando de Soto and the Florida Indians.* Gainesville: University Press of Florida, 1993.

Milanich, Jerald T., and William C. Sturtevant. *Francisco Pareja's 1613 Confessionario: A Documentary Source for Timucuan Ethnography.* Tallahassee: Florida Department of State, 1972.

Milanich, Jerald T., and Samuel Proctor, eds. *Tacachale—Essays on the Indians of Florida and Southeastern Georgia during the Historic Period.* Gainesville: University Presses of Florida, 1978.

Weitzel, Kelley G. *The Timucua Indians: A Native American Detective Story.* Gainesville: University Press of Florida, 2000.

Worth, John E. *The Timucuan Chiefdoms of Spanish Florida, vols. 1–2.* Gainesville: University Press of Florida, 1998.

On the Seminole and Miccosukee Indians

Covington, James W. *The Seminoles of Florida.* Gainesville: University Press of Florida, 1993.

Maccauley, Clay. *The Seminole Indians of Florida.* Gainesville: University Press of Florida, 2000.

Missall, John, and Mary Lou Missall. *The Seminole Wars: America's Longest Indian Conflict.* Gainesville: University Press of Florida, 2004.

Sturtevant, William C., ed. *A Seminole Sourcebook.* New York: Garland Publishing, 1985.

Weisman, Brent R. *Like Beads on a String: A Culture History of the Seminole Indians in North Peninsular Florida.* Tuscaloosa: University of Alabama Press, 1989.

———. *Unconquered People: Florida's Seminole and Miccosukee Indians.* Gainesville: University Press of Florida, 1999.

Wickman, Patricia R. *Osceola's Legacy.* Tuscaloosa: University of Alabama Press, 1991.

Online Resources for Florida Archaeology

Florida Museum of Natural History. Links on Florida archaeology. 2003. http://www.flmnh.ufl.edu/anthro/flarch/flinks.htm. [This URL will lead to a number of other pages and links, all dealing with Florida Indians.]

Theodore Morris is a commercial illustrator and graphic designer. He has hosted a number of solo exhibits of his Indian paintings, and two of his paintings have appeared on University Press of Florida book covers.

Jerald T. Milanich is curator in archaeology for the Florida Museum of Natural History. He has been involved in archaeological investigations in Florida and Georgia for over twenty years. He is the author of seven books dealing with the settlement of Florida and South Georgia, most recently *Florida's Indians from Ancient Times to the Present* (UPF, 1998).

Related-interest titles from University Press of Florida

Indian Art of Ancient Florida
Barbara A. Purdy

Florida's Indians from Ancient Times to the Present
Jerald T. Milanich

Florida Indians and the Invasion from Europe
Jerald T. Milanich

Unconquered People: Florida's Seminole and Miccosukee Indians
Brent Richards Weisman

The Apalachee Indians and Mission San Luis
John H. Hann and Bonnie G. McEwan

A Seminole Legend: The Life of Betty Mae Tiger Jumper
Betty Mae Tiger Jumper and Patsy West

Healing Plants: Medicine of the Florida Seminole Indians
Alice Micco Snow and Susan Enns Stans

The Calusa and Their Legacy: South Florida People and Their Environments
Darcie A. MacMahon and William H. Marquardt

The Seminole Wars: America's Longest Indian Conflict
John Missall and Mary Lou Missall

For more information on these and other books, visit our website at www.upf.com.